Faith: The Impact of Judeo-Christian Religion on Art at the Millennium

This exhibition is made possible by an Emily Hall Tremaine Exhibition Award. The exhibition award program was founded in 1998 to honor Emily Hall Tremaine. It rewards innovation and experimentation among curators by supporting thematic exhibitions that challenge audiences and expand the boundaries of contemporary art.

JANUARY 23 – MAY 29, 2000

The Aldrich Museum of Contemporary Art

Museum funding provided, in part, by the Connecticut Commission on the Arts.

Education funding provided by: The Alexander Julian Foundation for Aesthetic Understanding and Appreciation, The Barnes Foundation, Inc., The O'Grady Family Foundation, The Perrin Family Foundation, and the RJR Nabisco Foundation.

ISBN# 1-888332-12-3
©2000 The Aldrich Museum of Contemporary Art
258 Main Street, Ridgefield, Connecticut 06877

Designed by lookinglately, New York
Printed by Quebecor Printing, Canada

Cover: Kinke Kooi, *O, God* (detail), 1999

Curated by: Christian Eckart, Harry Philbrick, and Osvaldo Romberg
Assistant Curator: Jessica Hough

CONTENTS

ACKNOWLEDG-MENTS

Harry Philbrick

This exhibition is one of the most ambitious exhibitions the Museum has ever under-taken. The curatorial process was a collaborative one shared by artists Christian Eckart, Osvaldo Romberg, and myself. It has been my privilege to work with these dedicated and insightful colleagues. My most special thanks go to assistant curator Jessica Hough, whose intelligence, insight, and patience allowed this exhibition to be achieved, and whose high standards raised the level of achievement. Our curatorial meetings reflected the passionate and inquisitive interest in art, ideas, and belief which the curators brought to the process.

We are tremendously thankful to the Emily Hall Tremaine Foundation for granting us an Emily Hall Tremaine Exhibition Award. Without the Foundation's generous support, this exhibition would not have been possible. Emily Hall Tremaine, along with her hus-band Burton, was a significant art patron and collector with refined and courageous taste. The Exhibition Award named in her honor was created in 1998 to reward innova-tion and experimentation among curators by supporting thematic exhibitions that chal-lenge audiences and expand the boundaries of contemporary art. This was the first year that the Foundation awarded such a grant, and we are thrilled to have received the inaugural honor. We realize that, as one of the first grantees, our show has helped set the precedent for future awardees. We hope we have lived up to the high ideals of the Foundation and the distinguished jury whose decision it was to fund the project.

Putting together an exhibition such as *Faith* is costly not only for the Museum but also for individual artists making new work for the show. Sylvie Blocher's installation was made possible, in part, by help from the cultural services of the French Embassy. We are grateful to Antoine Vigne at the Embassy for advocating on her behalf. We also received a generous donation of electronic equipment from Philips Consumer Electronics which made Sylvie's elaborate installation possible. We are extremely grateful to Michel Bernard Broussard at Philips in France for initiating the donation and to Katie Vlack at Philips in Atlanta, Georgia, for getting the equipment to us in time for the opening.

Jo Yarrington also sought and found financial help for her installation which appears in the windows of all off-site venues and the Museum. Her work was funded in part by a grant from The Humanities Institute and a Faculty Research Grant, both from Fairfield University. Jo was ably assisted by Chris Durante, Gail Beiderman, and Kali Liston during the production of her piece, and Michele Gunning and Kristen Izzo dur-ing its installation.

Nicholas Kripal was the recipient of a much sought after Pew Fellowship in the Arts which made his new sculpture for *Faith* possible. Nick had to rent a larger studio and seek specialized help in order to make *Crown*, which was installed outside St. Stephen's Church. His mold makers, Shane and Julia Stratton, deserve special thanks, as do his assistants Daniel Cutrone, Jeremiah Misfeld, and Benjamin Shulman.

Several other artists were helped by their own assistants who traveled with them to the Museum. Deserving our greatest thanks are: Aurélien Conty (assisting Sylvie Blocher); Valerie Atkinsson, Thi Bui, Trevor Bui, Matthew Garrison, and Analia Segal (assisting Petah Coyne); Karen Leo (assisting Matthew Ritchie); Christopher Rincon (assisting Michael Tracy); and Ellen Wexler (assisting Allan Wexler). Thank you also to Wendy Moran, who volunteered her time assisting several artists.

Our own show change crew never ceases to perform miracles. They did three weeks of work in a two-week period. Assistant director Richard Klein oversaw art transport and the installation of the entire exhibition. It was a seemingly overwhelming job with countless details and Richard handled it all with enthusiasm. Heading up the show change crew were veterans Jonathan Bodge and Amos Prahl. They were ably assisted by Arnold Daley, Chris Durante, Holly Fracassi, David Haislip, Steve McAuley, and Tyler Smith. We appreciate their dedication (and occasional antics). We also thank Trish Berube for her meticulous condition reports and Mary Kenealy for excellent registrarial and installation work. The whole Museum staff worked extremely hard during the show change. Thank you: Pat Barratt, Nancy Bradbury, Nina Carlson, Elisa Flynn, Paul Harrick, Megan Luke, Anne Murphy, Robin Phillips, Maureen Shanahan, Barbara Toplin, Aran Winterbottom, and Melanie Zalman.

It took a very special group of people to build Osvaldo Romberg's outdoor installation *Syzygy II*. James W. Morgan did an excellent job overseeing the project and paying great attention to detail. He put the piece together during a cold December week with Paul Harrick, Todd Haight, Steve McAuley, Mark Psomas and Aran Winterbottom.

Justen Ladda took on a very ambitious sculptural project titled *Tree of Knowledge*. The stainless steel sculpture is draped in crystal beads donated by Swarovski which required many hours of hand work by paid assistants and volunteers. Gregory Barsamian, Nancy Buirid, Cynthia Fand, Kazumi Fukuda, Carrie Hill, James W. Morgan, Jennifer Pomeroy, Billy Reece, Dawn Sinkowski, Aran Winterbottom, and Mary Ziegler all assisted Justen.

We are grateful to all of the galleries which expressed enthusiasm for *Faith* and helped with the exhibition. Thank you also to the following collectors who generously

lent works: Dorothy Bandier; Ellen and Carl Bartholomaus; Boardroom Inc.; Laurel Cutler; Fisher Gallery, University of Southern California; Kenneth L. Freed; Luca and Nina Marenzi; Jane and Timothy McCaffrey; Creighton Michael and Leslie Cecil; Paul Monroe; Barbara and Ira Sahlman; Piet and Ida Sanders; Barry Sloane; Frederieke Taylor; Karen Veronica; and Mark Wlodarczyk.

We are especially thankful for the support we received from the religious institutions in Ridgefield, who not only agreed to host works of art on their grounds and in their buildings, but also embraced the artists and volunteered their time to help with the exhibition. Thank you to our new and old friends at The First Congregational Church, Jesse Lee Memorial United Methodist Church, St. Stephen's Church, and Temple Shearith Israel. We are especially grateful to Joanne Berg, Wendy Erich, Reverend Dick Gilchrist, Gail Gilchrist, Rabbi Jon Haddon, Reverend K.P. Hong, Reverend Dale Rosenberger, and Chris Tugeau.

We are also grateful to the panelists at the symposium we held at The Drawing Center in New York in October 1999. The panel was ably moderated by Marcel Brisebois, director general of the Musée d'Art Contemporain de Montréal. He, along with Eleanor Heartney, Michael Rush, Ori Soltes and Livia Straus, provided a fascinating intellectual overview of the terrain mapped out by the artists in *Faith*. Special thanks to Beth Finch at The Drawing Center for being such a generous professional colleague.

We are very lucky to have an exhibition committee at the Museum which is open and enthusiastic toward new exhibition ideas. I am grateful to Sherry Hope Mallin and Livia Straus for initially suggesting the idea for the exhibition to the committee. The catalogue for this exhibition was an especially involved undertaking. We are thankful for a new staff member in our office, Megan Luke, who did an excellent job assisting in the editing of individual essays and researching historical images to accompany them. Thank you to Jane Calverley for her patient and careful editing of the catalogue. Her efforts were above and beyond the call of duty as she transcribed the entire symposium. We are tremendously grateful to Catherine Vanaria for taking stunning photographs of the exhibition on a very tight schedule. Thank you also to Marion Delhees and Achim Wieland at lookinglately Design for their innovative catalogue design.

Finally, we are tremendously grateful to the artists whose work reflects their diverse and quite staggering achievements. It is an honor for all of us at this museum to work with such a talented and skilled group of artists.

CREATING *FAITH*

Harry Philbrick

Is religious art too explosive for contemporary art museums, as evinced by the reaction to Chris Ofili's *The Holy Virgin Mary* (1996) in the Brooklyn Museum's *Sensation* exhibition? I think not: that contretemps was fundamentally about politics, not religion. Rather, I believe curators have avoided religious art. In a profession dominated by what is new, contemporary curators and critics have become obsessed with being at the forefront of any upcoming development in art. This can lead to a dependence on art about art, art which mutates directly from the immediately preceding style. This cloistered view can also breed a curatorial and critical distrust of art which tends towards the overtly spiritual rather than the newest trend, and the adoption of a demeanor of critical detachment while one waits for *the next big thing.*

Indeed, religion becomes almost a curatorial untouchable when we evaluate this situation within the setting of an America where engagement with religion appears both ubiquitous and shallow—athletes crossing themselves before coming to bat, politicians who ostentatiously display their politically advantageous Protestant beliefs. When religion is broached, it is within some other critical context: heaven as a sociological construct; Mary as a gender symbol; Jewishness as a cultural condition.

However, every artist I have met intends to supply that very thing which the religious believer is seeking: some way to explain the mystery of existence. For many involved with art—myself included—art is a kind of replacement for religion, a way to embrace a higher sense of purpose and an attempt to resolve the enigma of what comes before birth, after death, and what transpires in between. What goes unmentioned in the art world today is the inherent connection between art and religion.

As numerous conversations with artists over the last year revealed, there are many artists making art about religion: artists whose work is built upon the armatures of doubt implied by a fall from faith, and artists whose faith is simply a given in their lives, quietly underlying their art. When questioned about the relationship of their work to religious concerns, nearly all of them said that no one had asked them about the religious component of their work before.

As Christian Eckart, Osvaldo Romberg and I began the process of putting together *Faith*, we quickly realized that we were bringing

distinctively different curatorial styles to the task. We agreed that we would focus on the Judeo-Christian tradition for two reasons. First, there is not enough room in the Museum to mount an encyclopedic exhibition, nor did we have the breadth of experience necessary to confidently assess the various religions of the world. Second, we felt strongly that we wanted to explore the art made in the context of the dominant religious and art historical influences of our Western culture. The history of Western art can, after all, be traced back through the centuries within the context of Judeo-Christian images, architecture, and philosophies.

We felt strongly that it was important to collaborate with local churches and synagogues, to attempt to bring art out of the Museum and into local houses of worship. At the same time, we hope that this exhibition will bring members of those congregations into the Museum.

Faith is ultimately not a religious exhibition; nor, however, is it a secular exhibition. It is built firmly on two presumptions, as are the great religions: that we are, as flesh and blood mortals, transient beings; and that there is a higher order or plan towards which we aspire. For thousands of years art and religion have mutually claimed these truths as their own, often in service of each other. Numerous art movements have implicitly or explicitly inferred and implied a close relationship between the divine and the mortal in subject matter, intention, or technique. One can think of work as recent as Barnett Newman's abstractions, or go back to the nineteenth century to Albert Bierdstadt's landscape painting, or to Renaissance art, Medieval illuminated manuscripts, classical Roman or Greek art, ancient Egyptian art and beyond.

Over the last thirty to forty years, however, most museums and curators have sustained the notion that art and religion are twain. And yet, even within such a seemingly secular movement as Pop art, Andy Warhol's work can be seen to be deeply influenced by religious art, particularly in such iconic images as *Gold Marilyn Monroe* (1962), or, more obviously, his numerous *Last Supper* paintings.

What remains a constant, no matter the artistic style of the day, is the human need to ask *why*. It is our defining characteristic. Any parent can attest to the fact that somewhere around the age of four the human animal defines itself as a human being by asking *why*, over and over again. As we mature, these questions simply gain complexity and patina. Through the arts, as with mathematics, science, and religion, we seek answers to these questions.

Herein lies the connection between art and religion today. I don't think many of the artists in this exhibition would be comfortable being characterized as giving definitive answers to these questions in their art. Art now asks questions of the viewer: it tends not to preach ideas but to beseech thought.

Of course, the many artists in the exhibition approach religion in a wide variety of ways, some more interrogative than others. For some of the artists in *Faith*, such as Lisa Bartolozzi or John B. Giuliani, painting is a way to express faith. For some, such as Matthew Ritchie, the Bible provides a rich text to mine, a framework upon which to build. For artists such as Christof Klute, Roland Fischer, and even Clara Gutsche, the architecture of the church provides fertile ground. For Helène Aylon, art can ameliorate the rigid, hierarchical, male dominated tradition of the Orthodox Jewish faith which precludes a woman's communion with the Lord. For Petah Coyne, art is a vehicle for expressing deeply ambivalent ideas and emotions about religion: a dissatisfaction with the church, coupled with a deep engagement with the precepts and strictures of religion. Coyne wrestles with what is good and true, just as the nun, priest, or rabbi might. Same goal, different road. A brief discussion of some of the roads traveled through the terrain of *Faith* follows.

Using paint or photography, real people or imagined, metaphoric transformation or straightforward depiction, artists such as Lisa Bartolozzi, Father John B. Giuliani, and Lyle Ashton Harris prod us to reflect on the human face of faith and the humility of the individual before God. With Clara Gutsche's work we also begin to explore not only people of faith, but also the edifices built to house their communion with the spirit. The various spaces of the nunneries depicted in Gutsche's work, all in Canada, are by turns mundane and elegant, plodding and soaring. Christof Klute, on the other hand, captures the institutional banality of many modern churches: rows of empty chairs waiting to seat the worshipers. The place of worship is, after all, the meeting place of both the spiritual and the earthly. This inside/outside, body/spirit dichotomy is elegantly and simply presented by Roland Fischer in his photographs of overlaid interiors and exteriors of cathedrals. The geometry of faith is traced in the Museum's sculpture garden by Osvaldo Romberg's marking of the floor plans of the Cishi Pavilion from the Buddhist Longxing Monastery (circa 971 AD); Lutomiersk, a Polish synagogue (late eighteenth century); the San Sebastiano Basilica of Milan (1577); and the Iranian mosque in Saljuq (555-1160). Made of eighteen cords of

rough-cut firewood, this work ties together the spiritual service of art and architecture in the context of nature. Nicholas Kripal's sculptures recreate churches—including St. Stephen's Church, just down the road from The Aldrich—as inverted vessels, open to the heavens. Jo Yarrington uses the power of particular visual images to link the four different off-site religious institutions with the Museum, binding them together with a ribbon of translucent photographs in their windows.

Artists Manuel Ocampo and Willie Bester create work which reminds one of the connection between the church, politics, and power in recent history. Bester's work is rooted in the white supremacist history of South Africa, while Ocampo speaks of the church's complicity in oppressing peoples in the Philippines and elsewhere around the world. In both cases the church was used as a tool of colonial power. In the same vein, the subject of Barbara Broughel's series of sculptures is religion and power in seventeenth century New England, as exemplified during the Salem witch trials. Using domestic objects to reflect the charges made against the "witches," Broughel has crafted sculptures which recognize each of the forty-two victims of those trials. Her work is based on the oddly mundane and personally specific manifestations of the alleged Devil's handiwork upon which the accusations rested.

Helène Aylon's work over the last decade has explored the insidious effect of power within a religious context; not power wielded by one race over another, but by men over women within the Orthodox Jewish faith. Aylon has struggled with the weight of tradition embodied by her devout mother, her late husband (an Orthodox rabbi), and within her own heart. How can she, as a woman, reconcile the teachings of her faith with the dominant male hierarchy whose traditions maintain both a sense of holiness and subjugation? Aylon attempts to reclaim the voices of her female forebears and express her pain and mourning that their voices have not been remembered.

Michael Tracy and Matthew Ritchie, by means of their chapel installations within the Museum, touch on the extremes of our intellectual engagement with faith. Ritchie uses the myth of the Holy Grail as a source for *Chapel Perilous*. In the myth, any seeker of the Grail would come across a chapel during their journey which appeared normal, but was actually the Devil's chapel, and thus filled with peril. Ritchie has used this story as a starting point for a meditation on the use and necessity of evil in the Bible. Indeed, in any story of good, evil is a necessary counterpoint: the one defines the other. Inside the chapel Ritchie has painted three pivotal moments from the scientific and religious

history of the universe which define dualism and choice: the Big Bang, the Fall of the Angels, and the Expulsion from Eden. Ritchie sees parallels between these events and the developmental stages of the individual: at birth we are separated from our mother (Big Bang), in late adolescence we leave home (Fall of the Angels), and as adults we make moral choices which have repercussions with which we must live (Expulsion from Eden). These moral choices are what define us as human beings.

Michael Tracy's work embodies the almost baroque excess of the rituals of faith, of our human need to explain and contextualise our passions, to clothe and embroider them. Tracy's installation in the Museum, *Chapel of the Damned* (2000), is intended to *be* an actual chapel, not a work of art *about* a chapel. His entire body of work over the last twenty-five years has embodied a similar commitment to an exploration of passion and redemption. Tracy's work is rooted in a Latin American tradition of richly decorative, ritualistic Catholicism. His work is also centered on the human body, and the history within Catholicism of deeply conflicted feelings regarding the body. Catholicism has grappled with the body as both the site of, and vehicle for, sin, as well as a reflection of the divine plan. Tracy's work celebrates the magnificence and baseness of both our bodies and our minds, and our need to accept these inherent contradictions, as well as our passionate need to aspire to atonement, redemption, and understanding through prayer, ritual, and beauty.

So too with Hermann Nitsch's ritual passion plays—his reenactments of the ecstatic and base human rituals which mark our earliest history. The vestments and liquids of the Communion are rooted in ancient practices; our animal nature embodied first in blood, then wine, now grape juice. The central sacrament of the Christian faith, the eating of the wafer and drinking of wine is, after all, about eating flesh and drinking blood: actual rituals too horrifying to reenact or make part of our civilized lives.

The architecture and implements of ritual are used by Allan Wexler, Claude Simard, and Jaume Plensa. Plensa evokes the church's role in marking and explaining the rhythm of life, the emergence and passage of the spirit, with his shimmering brass gongs, marked *BORN* and *DIE*. Allan Wexler has created numerous *sukkot* over the years. A *sukkah* is a portable space to house the harvest celebration during the Jewish holiday, *Sukkot*. The *sukkah* exalts both the bounty of the Lord, and the industry of man. Wexler's *Gardening Sukkah* (1999), an intricate construction of carefully-crafted components and ready-made objects, humorously plays

upon the connection between the ritual structure and an everyday garden shed. Simard's pulpit is more ambiguous: does it invite us upward towards the word and the light, or hold us down in our place, lording the word of God over us?

Petah Coyne's Madonnas, embedded in a white wall in the Museum's galleries, also embody an ambivalent relationship towards faith. The wall can be seen as either a pristine white plane, the passage to the other, the infinite, the sublime, the void; it can also be viewed, especially from behind, as just plasterboard and framing, with cast plaster sculptures locked in private ritual, shielded from the world.

Christian Eckart and Keith Milow use the rigorous simplicity of minimalist forms to suggest the most tantalizing of subject matter for artists, the sublime: that transcendent state of grace which is, of course, impossible to truly depict. So too does James Turrell, not only in his well-known earth and light works, but also with *Lapsed Quaker Ware*, his collaboration with William Burke and Nicholas Mosse. *Lapsed Quaker Ware* suggests the human desire to craft perfection. This impulse, which is at the heart of much art which attempts to depict the divine, can be considered variously as a holy effort reflecting the glory of God's creation, an impossible task, and even a forbidden effort leading to the veneration of false idols through various epochs in Judeo-Christian history.

It is, of course, an impossible task to adequately discuss art with words, just as it is impossible to depict God in a work of art. What can words add to the visceral energy of Reverend Ethan Acres's *Miracle at La Brea* or the *Golden-Book*-meets-the-Renaissance feel of Jan Knap's idealized Biblical scenes? Words can describe Andres Serrano's photographs, but cannot replicate the passionate mood of devotion.

Perhaps the essence of faith, and *Faith*, is most simply put in Diane Samuels's *Letter Liturgy (for Leon)*, based on a traditional Jewish folk tale. "Dear God," says a man in the folk tale, "I do not know how to pray, but I can recite the alphabet. Please accept my letters and form them into prayers." This human need to communicate is the essence of art, and at the core of this exhibition. This entire project is an attempt to provide a forum for contemporary artists to grapple with this visual alphabet; like Jacob wrestling with the angel in Gauguin's *The Vision After the Sermon* (1888), the result is based on both contemporary and ancient sources. *Faith* is a millennial snapshot of these two venerable and vital traditions, art and religion, with which we continue to wrestle.

the culture of the word and the culture of the image

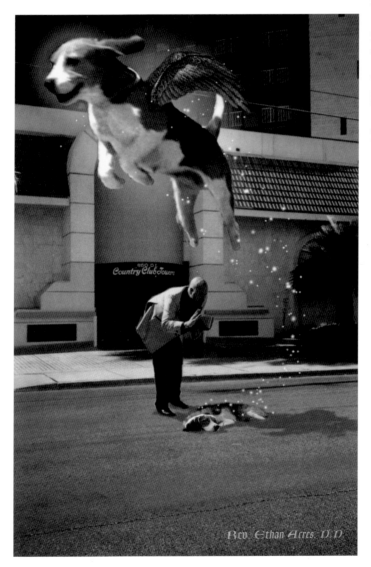

Rev. Ethan Acres, D.D.

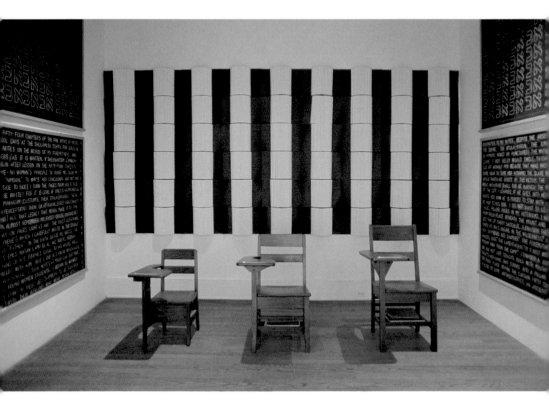

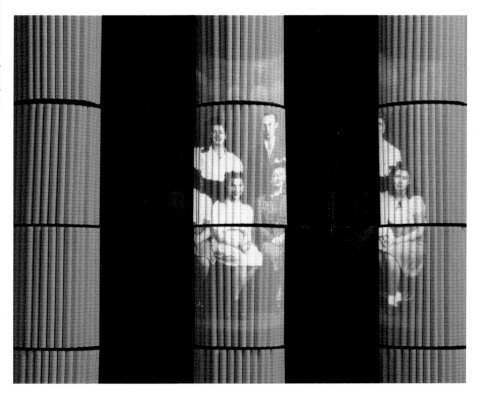

Heléne Aylon, *My Notebooks* (installation view and detail), 1998

Lisa Bartolozzi, *Her Creation* (detail and painting), 1997

Sylvie Blocher, *Living Pictures/Are You a Masterpiece?*
(installation view), 1999

Barbara Broughel, left to right: *Infant Goode*, *Dorcas Goode*, and *Sarah Goode* from *Requiem Series*, 1991

Barbara Broughel, *Mary and Philip English* from *Requiem Series*, 1991

INTERNALIZING THE SACRED:
THE INTERROGATIVE ARTWORK AS A SITE OF TRANSUBSTANTIATION

Christian Eckart

It is always a misrepresentation, of course, to speak of a linear evolution in the development of any theme in an artistic tradition. The truth is that developments seem to occur in a more fractally kaleidoscopic manner. It's only for the purposes of understanding, in hindsight, what has taken place that linear literalist generalities are imposed.

One of these that informs both my practice as an artist and my position in the collaborative curation of *Faith: The Impact of Judeo-Christian Religion on Art at the Millennium* is a progressive movement away from didacticism and tautology in Western art to an ever-increasing demand on viewer attention, engagement, and interaction in the subjective interpretation and utility of certain artworks. For the purpose of articulating my general thesis I have selected five paintings—spanning the Renaissance—of which I am particularly fond. Not only are these works of great beauty and craft, attributes that in themselves are critically constructive and productive (for a discussion regarding this point, see Elaine Scarry's *On Beauty and Being Just*), but they are also works of great complexity that beg for a heightened awareness in the viewer. I will proceed chronologically, assuming that the reader is aware that the Renaissance developed at different rates in different locales—often with unique results.

I begin with Cimabue's *Crucifix* (c. 1260) from Santa Croce in Florence. Art historians tend to locate the birth of the Renaissance with Giotto's Arena Chapel frescoes (1305-06). For me, however, all of the humanist precepts of Saint Francis have already been incorporated in this cross of Cimabue's. Byzantine stylization has given way to a relatively realistic depiction of an androgynous, almost hermaphroditic, figure. A revolutionary shift has taken place with this painting. The earlier hieratic, inert, flat and didactic representations of Christ have given way to a dynamic one that communicates more directly and viscerally with the viewer.

The delicate, sensuous, flowing form of Cimabue's Christ would have necessarily elicited strong emotional responses and feelings of empathy in the viewer not possible with earlier Crucifixions. I would further suggest that an engaged viewer would have been obliged to a sensual, even erotic, identification with this Christ. For me this gesture is nothing less than the extension of an expression of belief and faith beyond the precincts of heart and mind and into

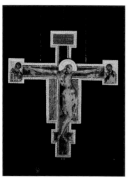

Cimabue, *Crucifix* (after 1966 flood damage and subsequent restoration), c. 1260. Tempera on panel. Museo dell'Opera, S. Croce, Florence, Italy. Photo: Scala/Art Resource, NY.

the body of the viewer/believer. More contentious to suggest here is the notion that the relative liberalism of the moment provided permission for Cimabue and others to reintroduce the feminine, an element of expression suppressed in their work for centuries in medieval Europe.

I do agree that Giotto took this extraordinary development of his mentor and teacher, Cimabue, one very great step forward with the aforementioned fresco cycle of the Arena Chapel. Rhetorically the shift from Cimabue to Giotto could be expressed as a shift from realism (an artificial, idealized likeness or representation) to naturalism (a more straightforward visual account). Giotto's frescoes would have generated a more immediate response from the viewer than prior pictorial expositions of the episodes of the life of Christ. For instance, one may have been able to recognize neighbors, relatives and friends in amongst Giotto's figures much as we recognize "types" today in the characters of the plays of Shakespeare. The scenes take on a new, more poignant aspect. They are more present in the here and now, depict activity that we could be participating in, and demand of us a more immediate association with their subjects. If Cimabue can be said to have unified, to some extent, the spirit, mind and body of his viewer, it can be said of Giotto that he situated this unified entity within a familiar social context.

Much of Renaissance art is occupied with the implications, refinement, and development of these revolutionary inventions and, for my purposes here, it is not until the late Renaissance or early baroque that the next important, non-formal, evolutionary transition takes place. Contrary to Giotto's natu-

Giotto di Bondone, *The Marriage of the Virgin*, 1305-6. Fresco. Arena (Scrovegni) Chapel, Padua, Italy. Photo: Cameraphoto/Art Resource, NY.

I. Marcel Brisebois: [from his introduction]: ... Furthermore, we have witnessed a decline in the alternatives to religion that developed in the past century and particularly, with the end of the Marxist regimes, the faith in revolution as a form of earthly salvation. As for the art that Hegel had raised to the mystic levels, it was stripped of its sacred aura in the work of artists this century. With the transition to the renowned "ready-mades," the relationship between the work of art and the everyday object was subverted, thus abolishing any alleged barriers between art and non-art. From then on, what was known as the aesthetic dimension was not based on any metaphysical or sacred property, but rather on the "use" made of the object and its relationship with another context, be it objective, institutional, or even ultimately commercial. The disenchantment of the world was matched by a corresponding loss of the spell cast by art, since, as Wittgenstein put it, the concept of use henceforth replaces that of revelation. — And yet, some people perceive a current swing back to religion. Could the return to religion be reduced, as some people tended to think, to fundamentalism, fanaticism, or some soothing New Age expectation? In the past century, say since the time of Nietzschean anarchism, the destruction of idols in general and moral standards in particular was the way to achieve personal emancipation. Suddenly, we have arrived at a configuration in which moral standards have again become central for the self-constitution of the individual. — Not moral standards as in a doctrine of sacrifice and a system of duty, but rather as in the ability to justify to oneself the reasons for orienting one's conduct, given the latest terms of one's condition and destination. Each individual has to personally ask these questions, and as an individual, inquire about the mystery of the world and the justifications for one's existence. What constitutes the soul of religious behavior is the quest and not the acquisition; it is the act of appropriation rather than of personal devotion. Religion today holds that religious discourse offers a hermeneutic perspective through which both this quest and this appropriation take place. The authenticity of the concern overrides the steadfastness of conviction as an exemplary form of belief, even as far as confession is concerned. — In this respect, artists are not a privileged breed, nor are they prophets, as suggested by the French philosopher Bergson. But questioned as we are, they become interlocutors with whom we can share our own soul searching....

II. Michael Rush: ... I'm interested in the association between the mystical and the religious —I mean the religious mystical and the artistic mystical—and how religion for many people (art has become a religion for many people) and the mystical experience that has often been associated with Catholic, Jewish, Islamic traditions can be experienced in unique and personal ways through the venue of art. But I look forward to more contentious issues, perhaps, tonight, too. **Ori Soltes:** ...My own interest, more broadly, is on, well, the relationship between religion in art and spirituality in art, as something which I believe goes back to the beginnings of art and which in that sense represents for ten or twelve or twenty or thirty thousand years a kind of continuity of concerns—even as over the course of all of those millennia the specific visual self-expression, the specific manifestation of such concerns, has changed, and no time is more

Symposium, October 8, 1999, The Drawing Center, New York City

subject to the notion of change than the time in which we live—and presumably some of that will come out this evening in the discussion which will ensue. **Eleanor Heartney:** ... I was raised as a Catholic, and that's actually very relevant to an investigation which I'm involved in right now. I'm looking at the relationship between contemporary artists of Catholic background and the kinds of often transgressive sexual body-related themes that their work seems to hold. I got involved in this investigation because, like a lot of people who were raised Catholic, I rejected the whole thing in my early adulthood. I decided that that was over and now I could go on and have my life. Then as I got older I began to realize that, in fact, it had really quite an important formative impact on me, and that it isn't something you dismiss so quickly. And at the same time that I was realizing that about myself, I began to become aware that a lot of the artists whose work I was interested in also came from this same sort of background, and moreover that a lot of the artists whose works were being most vilified by the religious right—Serrano, Mapplethorpe, Karen Finley and the like—also came from the Catholic backgrounds... **Norman Kleeblatt:** ... [W]e tend to define Jewish culture very broadly. So, my practice fits into a very broad definition of Jewish culture and art. I am always trying to deal with that nexus of art audiences and museum audiences and the very diverse Jewish communities that we also serve. It is a game to try to keep all those various balls in the air at once. I have actually found over the years that the specific religious art, as one might define it, plays a smaller role than art that addresses issues of identity and representation... **Livia Straus:** ... [F]or me there was a natural connection because Judaism seemed to be so imagery oriented, there was this kind of nebulous being or power or whatever that existed in the holy of holies, so it seemed to be a direct connection with not being able to have imagery. But the problem in Judaism was that in not having imagery there was also not that very specific figure that seemed to be reaching out and touching the person in a very imminent way. And in studying how Rothko and Newman used Catholic titles in the art they were doing, and Chagall used Catholic imagery in the paintings that he was doing, I discovered that there were also many other Jewish artists who were what I call borrowing symbols from the Catholic community, and artists in the Catholic community that were borrowing symbols from the Jewish community, and for me that was so representative of this pluralism that's emerging in, especially I think, in the United Status, this dialogue between the communities that is so reflected in the way the artists are presenting their material and giving us avenues not just to verbalize emotional attachment to a being through environmental art, through representational art, and through abstract art, but also a vehicle for expressing our responsibility towards other human beings, and not just towards other human beings, but towards creation in general ... III. **Marcel Brisebois:** So Livia, when you are thinking about religious art, how does it work for you? **Livia Straus:** For me it's very difficult and I've defined it for myself because it is the only way I can define it. For me, all art has a spiritual component, it's coming out of the spirituality and the *Weltanschauung*, the world presence of the artist. So in a sense there is no art that is not creative, that

Symposium, October 8, 1999, The Drawing Center, New York City

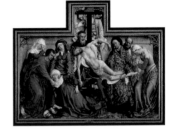

Rogier van der Weyden, *Deposition*, c. 1435. Oil on panel. Museo del Prado, Madrid, Spain. Photo: Erich Lessing/Art Resource, NY.

ralism is Rogier van der Weyden's use of purposeful artificiality. His *Deposition* (c. 1435) is a painting that seems to have emerged a century too early. Painted in a Northern, early Protestant context, the painting questions the historic reality of the episode but asks, nevertheless, what might be the meaning of this event/legend.

We see by looking at the ground upon which the action is taking place that it is meant to be a natural earthen surface. However, the background at shoulder-height of the figures is depicted as a shallow gilt wall—a kind of stage set. Furthermore, when one sees this painting in real life, one notices how the frame enhances the stage set aspect of the work. Van der Weyden has not painted the Deposition but, rather, a theatrical production of it, or the presentation of the Deposition as in a diorama. He has thrust the responsibility for the use of this scene from the life of Christ upon the viewer. I believe that van der Weyden has placed the highest demands and expectations on his viewer to be autonomous, freethinking and self-consciously engaged. The painting demands a level of critical reflection that we would today classify as Modern, as the viewer is forced to process contradictory and paradoxical signals and to assemble a reading from them.

To my mind, the single most radical achievement in painting of this period must be the de-romanticized representation of the body of Christ in state of Holbein's *Dead Christ* of 1521. Legend has it that Dostoyevsky was struck dumb upon seeing it. (See Julia Kristeva's *Black Sun: Depression and Melancholia* for an in-depth discussion of this painting.) The viewer is presented with a very dead, life-size body seen as if the side panel of a coffin or crypt had been removed. This confrontation with the mortality of Christ presents a test for the viewer. If one comes away from it believing that this body was henceforth resurrected, one is truly a believer and the "miracle" of the resurrection has been made all the more profound. The work presents Christ as a very dead mortal. It suggests that He is of the same stuff as you and I and, as such, prone to the same failings. The hierarchy that separates us and a more metaphysical representation of the Son of God has collapsed.

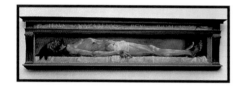

Hans Holbein the Younger, *Dead Christ*, 1521-2. Oil on panel. Kunstmuseum, Basel, Switzerland. Photo: Giraudon/Art Resource, NY.

Everyone living in sixteenth century Europe would have been familiar with corpses, and this corpse is like that of any other person recently among the living. The work demands a closer, more personal identification with Christ than that advanced by any other painting of the time. If Christ is of the same stuff as I, then am I of the same stuff as He? If He appears as one from among us, could He not, therefore, be among us now and be, potentially, anyone? This painting presents my ideal of a critically interrogative expression, demanding full viewer engagement. The viewer is obligated to assume the moral and ethical responsibility for its resolution, interpretation and attendant implications.

A far less conspicuously radical painting is Zurburan's *Agnus Dei (Lamb of God)* (1635). The viewer is presented with a still-life style presentation of an idealized lamb, legs bound, in a direct side view. It is my contention that Zurburan implicates all of humanity in the sacrifice of his lamb by presenting it to us in a prepared, and yet unmolested state. One must take into account the fact that Zurburan's portrayals of saints and martyrs were always depicted in a similarly idealized state, either prior to their martyrdom or as they appeared to his mind's eye in their post-martyrdom afterlife.

This device, contrary to almost all of the spectacularly dramatic and bloody depictions of saints and martyrs in art history, asks us to imaginatively re-enact the procedure of their torment, torture and death. Through the employment of this strategy, Zurburan makes each and every viewer virtually complicit in the sacrifice or martyrdom of his subjects. The statement here is that the responsibility for the event, and by extension, the guilt, is a natural consequence of being human. The painting is

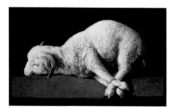

Francisco de Zurburan, *Agnus Dei (Lamb of God)*, 1635. Oil on canvas. Museo del Prado, Madrid, Spain. Photo: Scala/Art Resource, NY.

therefore a mechanism for leading the viewer to an assumption of, and confrontation with, the human condition within a Catholic theological and socio-cultural context.

The teleology that I am attempting to delineate here is one whereby the artists presented locate points in a continuum which, to ever-greater extents, presumes an interrogative, interactive engagement from their audience for the completion of their works. The viewer is implicated at ever-higher levels of expectation and subjectivity in the moral and ethical resolution, interpretation and instrumentalization of the works themselves. This development parallels that of the generally assumed expansion of Western subjective consciousness—from the end of the medieval period, through the Renaissance, into the Enlightenment—which becomes an aspect of the fundament of Modernism.

The location of the sacred is shifted from an external, didactic site to an internal and personal one. This necessarily implies an evolution from passivity to active, committed participation on behalf of the viewer. The resulting hierarchic compression presents the conditions for the individual to assume divinity oneself through autonomous, self-determined and critical identification with complex artistic constructions and their subjects. Historically speaking, it is this evolution that initiates the conditions for the romanticism and heroicism of the late eighteenth and early nineteenth centuries and that establishes the non-utopian aspects of an existential modernity. The artist, by placing such demands, responsibility, and expectations upon the viewer, does so as an act of generosity. By obligating the viewer to a fully conscious reception of such works, the mechanisms for self-realization, self-actualization, the consequent empowerment, and potential enlightenment of the viewer have been enabled.

I gratefully acknowledge the following people for their assistance in organizing the thoughts above: Mark Cheetham, Jessica Hough, Megan Luke, Luca Marenzi, Harry Philbrick, Matthew Ritchie, and Nancy Tousley.

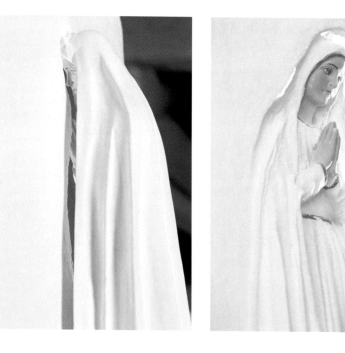

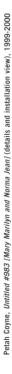

Petah Coyne, *Untitled #983 (Mary Marilyn and Norma Jean)* (details and installation view), 1999-2000

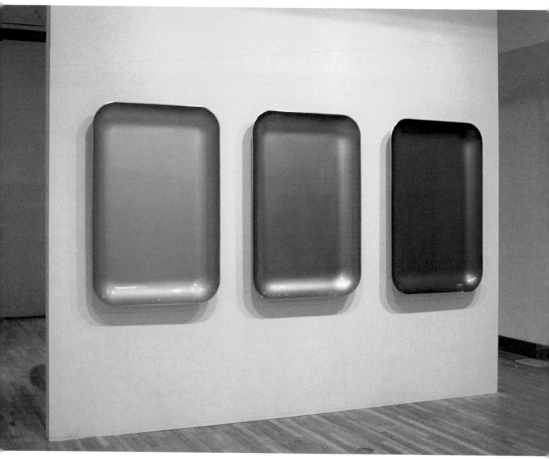

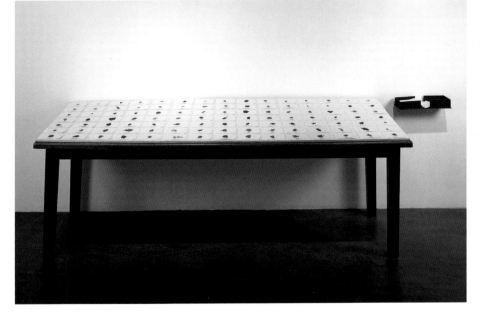

Linda Ekstrom, *Menstrual/ Liturgical Cycles*, ongoing since 1994

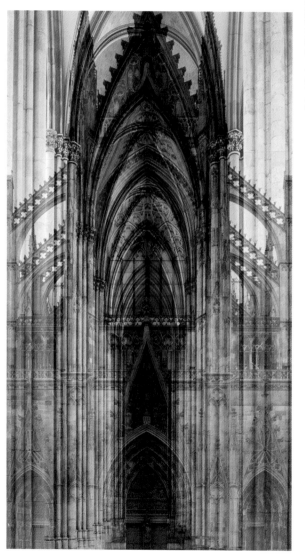

art is the longing of the person to find a place

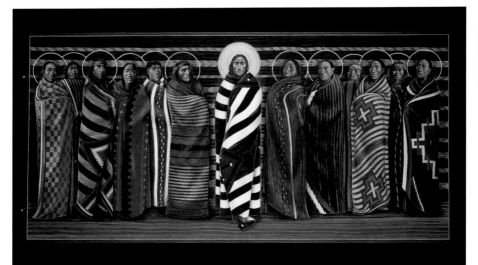

John B. Giuliani, *Jesus and the Disciples*, 1995

Clara Gutsche, *Le Monastère des Soeurs Adoratrices du Précieux-Sang, Utility Room, 1995*

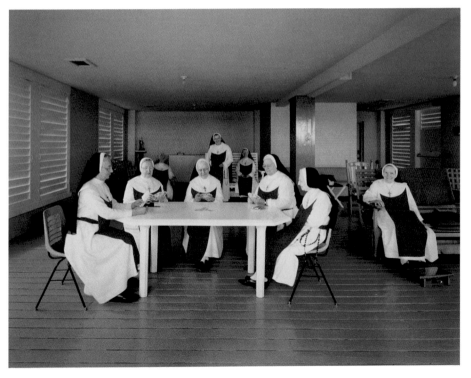

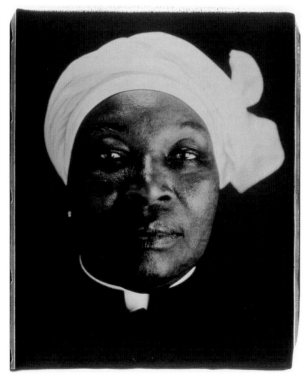

Lyle Ashton Harris, *Untitled (Face #34 Mother Dear)* and *Untitled (Back #34 Mother Dear),*
both 1998-99, at Temple Shearith Israel (installation view and close-up)

ART BE-
TWEEN HEAVEN
AND EARTH

Eleanor Heartney

Despite Western culture's rich tradition of great religious art, the contemporary world tends to see art and religion as enemies. Whenever the two are mentioned together, it tends to be in the context of some controversy or scandal, in which artists are accused of desecrating sacred images, insulting believers, or otherwise heaping their contempt on religion. The specter of the godless artist is perennially popular with conservative politicians seeking to eliminate government arts funding. And even within the art world, there seems to be considerable discomfort with the notion that faith and avant-gardism might share any common ground.

And yet any sensitive look at the contemporary art scene will reveal surprising numbers of artists who take their inspiration from religion in some way or another. They range from devout believers to those who are caught in the contradictions between the tenets of the faith in which they were raised and the realities of their lives in the modern world. Some artists struggle with the conflicts between religion and secularism, others explore the meaning of faith in an era of disbelief, yet others turn inward, seeking to discover how religious belief and religious training have indelibly shaped their own artistic imaginations.

This exhibition brings together a group of artists who reveal the wide variety of approaches taken by contemporary artists who engage the Judeo-Christian tradition in their work. These are serious explorations, the outcome of a sincere engagement with religion rather than a cynical dismissal of it. They range from the Reverend Ethan Acres, an ordained minister of the Church of Universal Life who combines the roles of artist and preacher, to Helène Aylon, who has been engaged for the last ten years in a critique of the harsh patriarchal code of the Torah; from John B. Giuliani, a Benedictine priest who melds the imagery of Native American art and Byzantine icons, to Allan Wexler, who creates settings for Jewish ritual celebrations out of unexpected materials.

These artists represent only a small cross section of those whose current work intersects with religion in some way. Yet, despite their efforts, the perception persists that contemporary art is antithetical to religion. This essay will attempt to

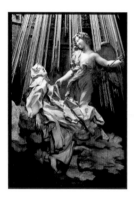

Gianlorenzo Bernini, *Ecstasy of St. Theresa* (detail), 1645-52. Marble. Cornaro Chapel, S. Maria della Vittoria, Rome, Italy. Photo: Scala/Art Resource, NY.

rectify this erroneous idea. It will focus on the impact which Catholicism has had on contemporary art, as that is my particular area of research. However, I believe the ideas explored here also have relevance to art works informed by other forms of Judeo-Christian faith.

It will be helpful, in order to understand where we are today, to look back at some of the great artistic expressions of faith from centuries past. We might begin with Bernini's sixteenth century masterpiece, the *Ecstasy of St. Theresa*. In a spectacular gilded alcove, flooded with real and sculpted light, the great medieval mystic is depicted as a beautiful swooning woman. As the point of an angel's arrow touches her heart, she flings her head back in a transport of emotion, indicating the overwhelming nature of her mystical union with Christ. This is one of the world's great devotional sculptures. It is also, as many commentators have pointed out, a remarkably accurate portrayal of a woman in the throes of sexual climax.

Is it disrespectful for Bernini to use such a common, carnal experience to give physical form to the experience of religious ecstasy? Or is it a sign of his genius, evidence that he realized that the ineffable can only be effectively expressed in a visual language which draws on familiar and immediately recognizable experiences? Like all the paintings of the Madonna and child which place this biblical pair in cozy domestic settings similar to those enjoyed by the paintings' original viewers, Bernini gives faith a human face.

Similarly, Mantegna's *Saint Sebastian* belongs to a genre of work which celebrates the willingness of the martyrs to endure painful tortures and death in the name of their God. However, Mantegna has depicted the saint as a gorgeous young man, who is charged with life and erotic energy even as he twists against the impact of the arrows shot into him. Again, an

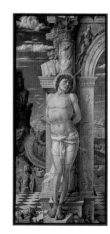

Andrea Mantegna, *Saint Sebastian*, c. 1460. Tempera on panel. Kunsthistorisches Museum, Vienna, Austria. Photo: Erich Lessing/Art Resource, NY.

undeniable sexuality permeates the work. Is it sacrilegious for the artist to introduce the realm of sensual desire into this scene of self-sacrifice and spiritual submission, or is Mantegna suggesting that Saint Sebastian's physical beauty can be read as a metaphor for his spiritual perfection?

Despite their erotic undercurrents, no one disputes the spiritual content of such historical works. Yet when contemporary artists combine physical and erotic elements with references to religion, they run the risk of being charged with blasphemy, profanity and denigration of the beliefs of the faithful. What is going on here? Have we lost our ability to look at the great religious art of the past and understand its connection to the human world? And has this consequently made us blind to the complexity of the religious expressions which appear in the art of our time?

The most recent in a continuing series of art scandals involves a painting entitled *The Holy Virgin Mary* (1996), by the British artist Chris Ofili. The work represents an Africanized black Madonna whose breast is bared in the manner of countless Renaissance depictions of the Virgin Mary suckling her child. Hanging from the breast like a large nipple is a black ball of a hard substance which turns out to be elephant dung. Ofili's ethnic heritage is Nigerian, and he has explained that his work represents an effort to explore his African heritage in the context of contemporary Western art. In this context, dung turns out to be a symbol of fertility, giving an African spin to traditional Christian representations of the Virgin Mary as the Mother of God. Meanwhile the Virgin is surrounded by tiny photographic cutouts which function from a distance like traditional putti, but are revealed close up to be cutouts from pornographic magazines.

Despite the fact that Ofili is himself a practicing Catholic, a firestorm erupted when this work appeared at the Brooklyn Museum in the fall of 1999 in an exhibition of the work of young British artists entitled *Sensation*. Erroneously describing the work as "a depiction of the Virgin Mary splattered with excrement," critics accused the artist of disparaging the Catholic religion. The word "dung" had become a red flag, making it impossible for them to see this work as an unorthodox rethinking of a venerable religious subject.

The Ofili controversy echoed an earlier controversy over Andres Serrano's *Piss Christ*, known to much of the world as "the crucifix dipped in urine." Again, this description misrepresents this photographic work, which actually presents a white

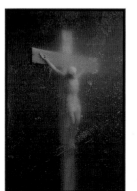

Andres Serrano, *Piss Christ*, 1987, Cibachrome, silicone, Plexiglas, wood frame. Courtesy Paula Cooper Gallery, New York.

crucifix flooded with a luminous field of golden yellow light. The liquid of the title turns out to be the medium through which this very beautiful effect is achieved.

Like Ofili, Serrano is engaged in a respectful reinvention of religious imagery. This work is one of a series of works in which religious artifacts are shot through body fluids, among them blood, milk and water, creating effects which give them an aura of unearthly beauty. Serrano's use of body fluids is in keeping with a tradition in Western religious art and literature which presents the blood of Christ, the milk of the Virgin and even, somewhat more obscurely, the semen of God, as the elements through which the miracle of Christ's incarnation made human redemption possible.

A final example along these lines is Robert Gober's untitled chapel installation, first presented at the Museum of Contemporary Art in Los Angeles. Another multilayered work, it centers on a devotional statue of the Virgin Mary whose womb is pierced by a drainpipe. She presides over a white minimal space, flanked by a pair of open suitcases. The viewer who comes closer, however, realizes that the first impression is only half the story. In fact, this is a work about the multiple realms of flesh and spirit, life and death, heaven and earth. The Virgin stands on a grate below which one can glimpse a lush tropical grotto, over which hover the dangling legs of a child and a man. The far wall opens into a staircase filled with running water which leads to an invisible upper level. The suitcases suggest a rite of passage between the ordinary realm of the gallery itself and the mysterious, spiritual realms above and below.

Again, this work was controversial because critics failed to see the interconnections between its different layers. It was, for them,

Robert Gober, *Untitled* (installation view & detail), 1995-97. Mixed media. Photo: Joshua White (installation), Russell Kaye (detail). Courtesy of the artist.

doesn't have a religious aspect, so in order to draw some sort of a differentiation, for me "religious art" is art that has some sort of religious symbolism, whether it's a crucifix, whether it's mythological imagery as in Keifer's *Lilith* series, that would separate for me the religious art from the art that has a spiritual entity to it. Michael Rush: ... Religious art per se for me would be art that has a certain iconography that can be identified as religious. However, I think religious art can be anything that involves the intentionality of the artist such that they say, he or she says, that this is religious in nature to them and therefore it should be—if they go so far as to say that this is religious, this art has religious components—we should investigate it as such and feel it as such. But I also think religious art can be extended, I would want the notion of it to be elastic enough to include art that touches one in a way that is spiritual even if the intention of the artist is not to create something that is religious. I think to me, in my own personal experience of art, that is what is great about it, that it allows for what might be conflated as religious and aesthetic transcendence. Marcel Brisebois: Eleanor, would you agree with that? Eleanor Heartney: ... I'm interested in art that comes out of religion, or comes out of a religious world view but isn't necessarily posing itself as religious art. I'm talking about work where you can read the artist's connection to religion. Just an example, I'm thinking about Andy Warhol who, it's recently been revealed, was a practicing Catholic, and was actually very involved in religion in a kind of subterranean way. There's currently a show right now at the Guggenheim of his late *Last Supper* paintings, and a book was recently written about these, which posed them as his most spiritual religious statements. But it seems to me that while it's true that these are the works of his that have the most explicit religious symbolism, the works that to me are really the most religious, the most Catholic, the most spiritual, or whatever, would tend to be earlier works. For instance, the *Electric Chair*, which I find a very profound image, could be likened to a contemporary version of the crucifix. And the icons of Jackie Kennedy and Marilyn Monroe are permeated with this sense of mortality and death, and also of sainthood. So it seems to me what I'm interested in is not really religious art per se, if that means art that is in some way explicitly manifesting a religious position, but rather a realm of art which comes out of a religious sensibility, but doesn't necessarily proclaim itself as such even to the artist.... Ori Soltes: There is, of course, a whole series of dichotomies that have just been set in front of us and I think are very reasonable ones, the dichotomy between the intention of the artist and of what the audience perceives in the work of art, and the question of whether the audience perceives the same thing that the artist intended or not, and whether that matters, and whether if we are to judge something in this case as religious, the artist has to have had a conscious intention to produce something that is religious, as opposed to unconscious, and whether the audience will recognize it or not. Marcel Brisebois: We'd like to hear from you, Norman, now. Norman Kleeblatt: ...There is a large body of work that keeps growing that is called Jewish art. I never consider myself part of that practice, I find it amorphous, confusing, dangerous. Is a mural by Motherwell, a Christian artist, for a synagogue in Summit,

Symposium, October 8, 1999, The Drawing Center, New York City

New Jersey, Jewish art, or is it Protestant art, or is it just postwar art? Is Rothko's painting for the Menil Chapel Jewish, Christian, non-denominational, or just spiritual? I am interested in exploring the cultural signifiers one finds that complicate contemporary art and connect it to some kind of religious, cultural, or ethnic tradition. Jews were only allowed to begin to practice art—painting and sculpture—in Western countries in the early to late nineteenth century. They couldn't attend art schools before that time, they were closed to Jews...
IV. Ori Soltes: ... [I]t occurs to me of course that one of the more interesting things with respect to Jewish artists is that they are consistently part of a minority and therefore whereas, all things being equal, a Christian artist may not have to—be he/she Catholic or Protestant—ask about the history of Western art and where I fit in, because the history of that art is essentially Christian... yet the Jewish artist has to ask him or herself, Where do I fit into that? ...
Eleanor Heartney: ... I have a problem with the idea of Christian art as a kind of monolith, and in fact a lot of the research that I've been doing has really been about differentiating between this sort of Catholic body-based imagery with a sensual, sexual kind of an aesthetic, versus what I see as this country's more dominant Protestant, puritan-based approach. I see the latter as a more word-based, abstract-oriented, and more non-corporeal kind of an aesthetic. In fact one of the things I hypothesize is going on in the so-called culture war is that the aesthetic of Catholicism, which is a minority position in this country, is coming into conflict with the dominant Protestantism. Part of this clash really has to do with these different world views and this notion that, in a word-based culture, there's a tendency to not be able to see the complexity of an image like say *Piss Christ*, or the Chris Ofili *Holy Virgin Mary*. Instead they get reduced simply to glib verbal descriptions. I think that that relates to a tension in American culture between the culture of the word and the culture of the image, which I see also as a Protestant versus Catholic tension. So I want to make a distinction within the notion of Christian art to point out that there is also another dynamic going on there. Marcel Brisebois: If I may add something, and I don't want to interrupt the discussion between you who are very scholarly people, but we should make also a difference between Catholics— Spanish Catholics, French, Italian and so on ... Eleanor Heartney: Yes, absolutely, yes. Marcel Brisebois: They have very different traditions and being from French descent I must say that sometimes it is very difficult for a French person to look at, for example, the parade, if I may say so, because sometimes it is more a parade than a procession, that they have in Spain on the occasion of a Good Friday or the Assumption of the Virgin. We are shocked by that from the French point of view, the French tradition, we are not used to that specificity and there we come to the issue of the body. The French tradition is more intellectual, more abstract, than the Spanish one, so there are a lot of nuances when you speak about Catholicism or Protestantism, I think. Eleanor Heartney: Actually I think that a lot of the most visible American artists from Catholic backgrounds are of Spanish descent, because they tend toward a more visceral, physical imagery that stirs a lot of flak. Michael Rush: Do you think that the work that is getting flak is the work that does deal explicitly with

Symposium, October 8, 1999, The Drawing Center, New York City

simply a Virgin Mary impaled on a pipe. The idea of the pipe as a conduit of grace, or Mary's womb as the sacred place where God became man, was once again lost in a one-dimensional reading.

The examples illustrate that art that deals with religious themes by definition must not be taken at face value. Because it crosses different realms of existence, linking earth and heaven and encompassing both the physical and the spiritual, religious art must be understood on multiple levels. Manifestations of invisible forces are made perceptible through metaphors drawn from the physical world. This requires a habit of complex reading which, unfortunately, seems increasingly rare in a contemporary world inured to the mass media's instant messages.

Andy Warhol, *Little Electric Chair*, 1965. Synthetic polymer paint and silkscreen ink on canvas. Photo: The Andy Warhol Foundation, Inc./Art Resource, NY. © 2000 Andy Warhol Foundation for the Visual Arts/ARS, New York.

The artists discussed above make explicit reference to religious themes. But I believe religion shapes the imagination of artists raised in specific artistic traditions even when they are not dealing overtly with the subject, and even when they have a conflicted relationship to that tradition. I would like to close with a discussion of two other artists from Catholic backgrounds whose work takes on new dimensions when read through a religious lens.

The first is Andy Warhol, who, recent scholarship has established, was a devout and practicing Catholic even at the height of the Factory years. Warhol occasionally dipped into religious subject matter, adapting icons like Raphael's Sistine Madonna or da Vinci's *Last Supper* to his signature Pop style. However, while his treatment of these motifs seems indistinguishable from that of other more secular trademarks and logos, I believe one can detect the depth of his religious feelings more accurately in other works which have no obvious religious references. His portraits of Jackie Kennedy and Marilyn Monroe, for instance, have the solemnity of religious icons, and their association with tragedy gives them a profundity lacking in many of his other society portraits. Similarly,

Warhol's depictions of the empty and isolated electric chair represent the loneliness of death at the hands of the state, and thus might even be seen as a contemporary version of the crucifix.

In contrast to Warhol, Robert Mapplethorpe was a lapsed Catholic. But like Warhol, his artistic imagination was nevertheless indelibly marked by his early exposure to religion. In fact, he once confessed to an interviewer that his greatest influences as a child were Coney Island and the Catholic Church. This artist, notorious for his explicit photographs of homosexual acts, is not usually associated with religious themes. Nevertheless, a closer examination reveals Catholicism's profound impact on his work. This influence can be seen in formal aspects of his work—for instance the iconic centering of figures, the dramatic use of light that flows over figures like the radiance that permeates sacred figures in traditional religious art, and the recurring use of the triptych format which echoes traditional altarpieces.

But even more profoundly, Mapplethorpe has adopted the Catholic themes of spiritual desire and the search for perfection to his own ends. In his hands, the visual language of religious art is redirected toward a longing for redemption through carnal desire and physical beauty. This is particularly evident in a work like *Dennis Speight*

(1983), in which Mapplethorpe has borrowed the pose and even the symbolic attributes to be found in traditional depictions of the risen Christ, while inverting the context to speak of homoerotic desire.

Mapplethorpe's conflicted relationship to his childhood religion is at the far end of the spectrum from Serrano's serene acceptance or Gober's nuanced embrace of the duality of heaven and earth. Yet in a society where belief is forever being challenged by secular skepticism, where knowledge of the oppressive history of religion coexists with recognition of its liberating potential, and where body and spirit exist in tumultuous relationship, all such responses to the challenge of faith in a secular age are valid. Works by artists like those in this exhibition reveal that, far from being adversaries, art and religion are inextricably linked together, and without them we will fail to understand the deepest aspects of human experience.

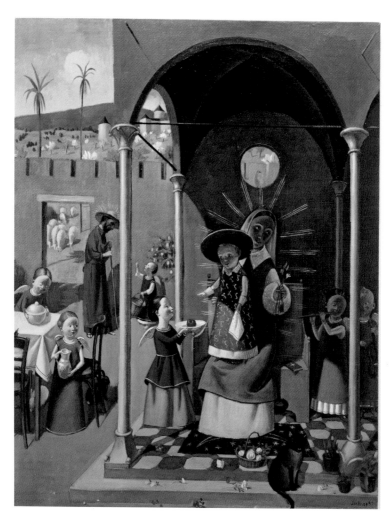

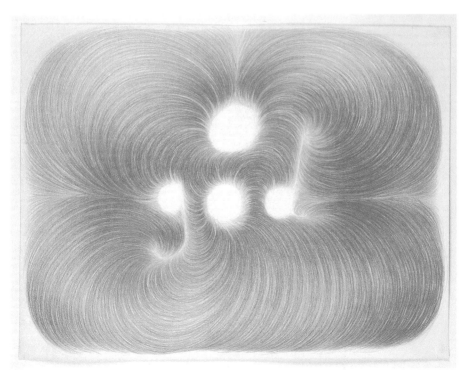

Kinke Kooi, *O, God*, 1999

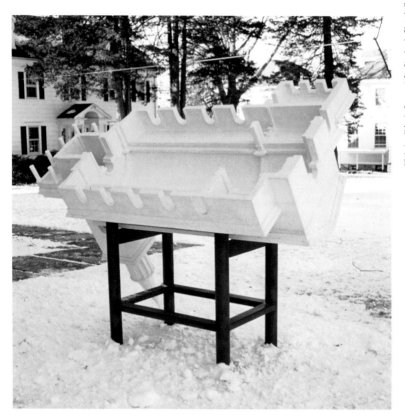

Nicholas Kripal, *Crown* at St. Stephen's Church (installation views), 1999

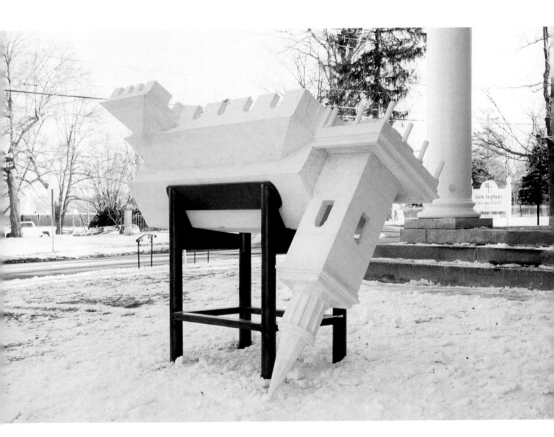

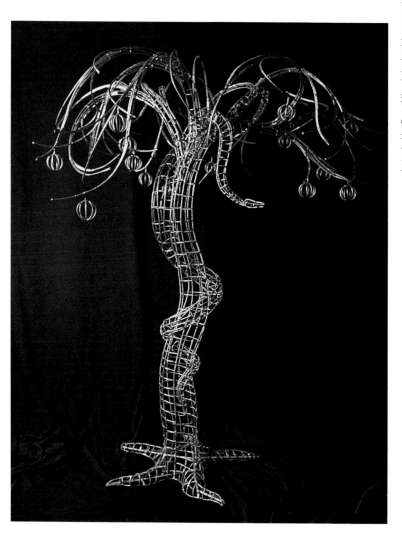

Justen Ladda, *Tree of Knowledge* (work in progress), 2000

Maria Marshall, *I'm not going to die easily* (video still), 1999

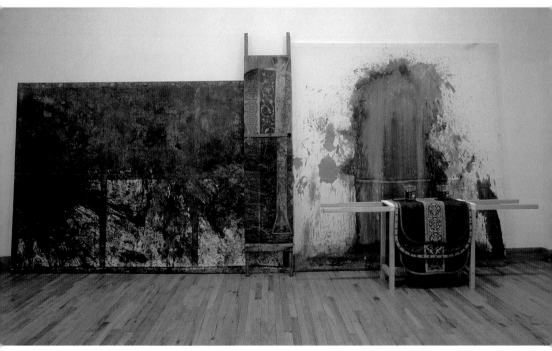

ART TO ART. LIFE TO LIFE.

Osvaldo Romberg

"It is not that religion is delusional by nature, nor that the individual, beyond present day religion, rediscovers his most suspect psychological origins. But religious delusion is a function of the secularization of culture: religion may be the object of delusional belief insofar as the culture of a group no longer permits the assimilation of religious or mystical beliefs in the present context of experience."

Michel Foucault, *Mental Illness and Psychology* (1962)

Art begins when life is not enough...

ART

RELIGION

In modern culture the acceptance of death signifies the loss of connection with the infinite. It is in this area of thinking, in the loss of the infinite, that art gives relief and new hopes for spirituality.

Art makes evident (and occasionally succeeds in resolving) the conflict between being and integrating with the world. This is a dilemma which religion can no longer address.

Art should, in the words of Antonin Artaud, "create a metaphysical framework for the word, the gesture and the expression, to rescue them from their enslavement to psychology and human interests." (*Van Gogh, le suicidé de la société*) He was seeking a metaphysical context allowing art to address the fundamental problems of the human condition.

When Caravaggio humanized Christian icons by painting ordinary people, Velázquez and Rembrandt immediately reversed the trend, and re-aestheticized the world of God for Christianity.

The power of art resides not only in its semantic strength, but also in its capacity to create models for metaphysical enigmas. The number of the models is infinite. Their flexibility permits them to function at different levels of the psyche.

All the religions of the world are narratives. In these narratives are implicit mythologies and explanations which help people to survive the panic of death and solitude. In the past, art merely articulated these narratives. In recent years, however, I have observed that art is replacing religion by raising its own issues of morality, identity, mortality and transcendence.

Art used to be an illustration of the metaphysical. It has now become the metaphysical itself. The vitality and dynamism of contemporary art challenges religion's ability to face the relevant issues of the end of the millennium: artificiality, reproduction of the species, and equality.

The search for originality, so typical of the modern artist who claims to be unique, is shaped by our idea of God as creator. From nothing, God created matter and the organization of matter, which is life. The artist takes white canvas, organizes it, and creates meaning. It seems that the mission of the artist is to create meaning for others. Is that not a religious endeavor?

ART

The metaphorical nature of art touches the spiritual while bypassing reason and intelligence. Art is where the organic and metaphysical meet that unique place where pure signification can be found.

Art is not only able to signify, it can also mesmerize and awaken the miraculous. It contains the secrets and revelations of existence.

Paraphrasing Martin Heidegger, we can say that the authentic dialogue with the art of an artist is artistic, as opposed to critical. There is an artistic dialogue between artists and those who do not believe in the power of art to contain essential truths. Non-believers can, but will not, participate in this dialogue.

Heidegger showed and established after Johann Christian Friedrich Hölderlin that a poem (a work of art) replaces philosophy. He declares that philosophy is a prisoner of science (positivism) and politics (Marxism).

In a sense, conceptual art returns to Judaism as it eliminates the image and focuses on the word.

RELIGION

Lautreamont speaks about the insatiable thirst for the infinite. Looking for the infinite is the fundamental model for every artist. It arises from our confrontation with death.

The artist is a transformer, an alchemist converting space to time and time to space. Like religion, art promises the transcendent and the eternal.

Maurice Merleau-Ponty, in his short but insightful booklet, *The Eye and the Spirit*, claims that all the paintings of the world are the same and only painting. All of the religions of the world, in different languages, times and places, praise the same God.

The difference between art and culture is like the difference between faith and religious practice.

It is possible to view our culture's insistence on a Judeo-Christian dichotomy as an artificial separation. Perhaps Jews are proto-Christians, and Christians are dissident Jews. Both religions have benefited from the influence of Moses, who, incidentally, was probably Egyptian and derived his ideas from Akhenaton.

ART RELIGION

The hermeneutic tendencies of modern art can be related to the Jewish practice of Talmudic study, essential to the everyday life of a Jew on every social level. For Jews, the answer is also a question.

Interpretation takes us out of creation to another domain, the domain of explanation.

For a true artist, the world of art is reality, and the world of reality is a corporeal fiction. That is why it is difficult for artists to function in both worlds.

It is easier to gain understanding of the energy of the cosmos looking at a Pollock than listening to a lecture by a scientist.

Perhaps history is nothing more than the conflict between those who try to alleviate the human condition by show-

For Giambattista Vico the triad of language, art, and myth (in the last word I can read "religion" if I consider myth and religion interchangeable at certain moments of civilization) represents the true unity of human culture. Vico also speaks of three kinds of language. The first is wordless; it consists of gestures. The second, "heroic language," is constructed with similitudes, comparisons, images and metaphors. Finally, the "human" language consists of "conventional," agreed-upon expressions. These aspects (language, art, myth), which

Marcel Duchamp, who did to representation what Friedrich Nietzsche did to religion, used the ready-made to "present," not to "represent." Johns and Rauschenberg, etc., are the "counter-reformers" who collaged real objects into the representational space of their paintings.

ing mankind a road to the supernatural, and those who want to reduce man to a positivist, scientific explanation. There will be those who idolize technology as a new God, and those who praise the mystery which art embodies.

closely resemble a description of religious liturgy, are clearly present in the work of installation and video artists, as well as in many multimedia presentations. These contemporary artists produce important metaphors that allow them to convey

religious symbols, isn't that correct? The flak? Eleanor Heartney: Oh yes, the flak does seem to come from religious symbols. Michael Rush: So the question that I have is in regard to this. Is it of interest to raise the question that if somebody is going to do art that does have a shock element to it, or does deal specifically with religious symbols, do they have a responsibility in some ways to educate what it is that they are doing? It's really just a question, I wouldn't want to make any artist say that they had to explain what they are doing, but if they are going to engage volatile symbolism, is there perhaps a responsibility, a social responsibility, to say this is what I'm doing and this is why I'm doing it?

V. Norman Kleeblatt: I think that there are always going to be different communities and that the multicultural era taught us to never think about anything as hegemonic. Communities are going to react differently. I've shown things at The Jewish Museum where I didn't have to worry about an outside agency, an outside culture, censoring us. Yet some specific Jewish communities might find the work way too challenging and too interrogative of assumed authority or propriety. What one does is try to explain the art to the visitor before they walk into the space. In one particular case, Helène Aylon's *Liberation of G-d* that I showed in 1996 was a long conversation between the artist and God—a particularly Jewish concept. That was a contentious work, which needed to be mediated for the visitors. Some visitors still hated it and ran out screaming, but they knew before that there was going to be something that might upset them. What's so fascinating about some of the Jewish artists who deal with those issues is they are using their art to understand their place within the religion. I think that that's where we don't cut enough slack for artists who are taking challenging positions. They are really questioning, What am I part of? Part of the art world, and part of this religious tradition? Artists may try to integrate the two. These two are really moving pieces of their personal identity. How do I do that, and how do I create a dialectic that's going to allow me to speak to various audiences? are questions they pose. In Helène Aylon's case, this may be non-Jewish friends in the art world, in Andres Serrano's, non-Catholic friends in the art world. Both their work comes out of art historical traditions and religious traditions. They carry baggage and a real affection for certain aspects of religion. Otherwise those images and texts wouldn't remain so closely connected to their practice.

VI. Marcel Brisebois: According to the German historian, Hans Belting, in his book *Bilt Und Kunst*, there is a difference between sacred and religious art. Since the sixth century to the Renaissance there was sacred art and after that there was no more sacred art but religious art, the difference being that sacred art is expressing itself through a code. Since the Renaissance, there are no more codes, but rather the self-expression of the artist reacting to religious subjects. Michael Rush: Actually, what that makes me think of, something that I've come to later in life, is that religion or religions are a form of longing, they are a form of the human reaching out to express a longing for understanding, a deep longing, a deep longing to make meaning in this world and I think art is very similar to that. The artists who grew up in a religious tradition, which would be most artists, what they take from that religion—whether or not they

Symposium, October 8, 1999, The Drawing Center, New York City

are still a practitioner of it or someone who's reacting to it in a negative way—what they've taken is that sense of longing I think, that sense of longing to express something beyond themselves, something that reaches beyond their immediate or something that delves so deeply into the moment that their expression is no longer religious per se, that involves religious codes, but involves personal longings that take the form of art—I mean that's what contemporary art is to me.... **Livia Straus:** What goes through my mind is the Hebrew word for sacred, which is *kadosh*, which really means separation and by separation we mean that there are certain boundaries set up that differentiate the sacred from—I won't even say profane—but from the secular. We know that those regulations have not remained static throughout history, that's why certain of the figures in Christian art have had loincloths drawn on them and then loincloths removed from them. But, yet there have been certain regulations that have been in place so that there is a sense that *this* is holy space versus *that* space, and one of the issues that's come up, I think, in the recent dialogue with the Brooklyn Museum, is what role that type of art has in a museum setting and can you monitor what is a sacred image when it's not in a sacred place. But I would contend that there are specific sacred objects and sometimes the sacrality of the object conflicts with ownership. By that I mean with the feminist movement there are many images, iconographic images, that the woman wants to own as her own, whether it's the image of woman as in Renée Cox's pieces as the Jesus figure, that the woman is also part of the God-being. Elizabeth Johnson wrote a wonderful book called *She Who Is* where she talks about the feminine side of the Trinity. Does that in a way conflict with the sacred imagery as it's been defined by the church, or with Helène Aylon when she was working with *The Liberation of G-d*? The concept of actually unscrolling a Torah and laying the tracing paper over the Torah script somehow crossed a border in terms of the protection, or the boundary between utilizing the Torah, which is a sacred object, that way and taking a book which is a printed object and laying tracing paper over it, and even that there was some issue with, but at least it wasn't to the other extreme. So I think there is a code. I remember a number of years ago, and I don't know if it is still in existence, there was actually a school for the sacred arts in lower Manhattan which taught how to do iconography, so there was a process, there were regulations in place. And I think there's a certain comfort that we have in society in having that type of a structure.
VII. **Ori Soltes:** Of course we live in an era where you not only have religious art in a museum, which is nominally a secular space, even though the very word means "temple to the muses" and had sacred implications when it was first used by the Greeks. But on the other hand you have churches and synagogues by the thousands that have turned themselves in effect into art galleries because of the perceived relationship between art and spirituality, or art and the specific religion of a specific institution.... **Eleanor Heartney:** ...
[G]enerally my feeling is that a lot of work that gets called sacrilegious these days is not, in my definition, sacrilegious, or at least, that doesn't seem to me really an interesting category. It's more interesting to talk about this notion of the sacred versus say the reli-

Symposium, October 8, 1999, The Drawing Center, New York City

ART RELIGION

Art can be viewed as an anti-dote to the static and para-lyzing force of religion in a post-capitalist, globalist era.

Roland Barthes saw in Scheherazade, the heroine of *Arabian Nights*, a height-ened metaphor for literature [art]. Scheherazade defeated death [thus obtaining immortality] by capturing the Sultan's imagination each night by means of storytelling.

The idea of art as a regenerative activity is described in *The Glass Bead Game*, by Hermann Hesse, which I read in my adolescence. The book is about the translation of all information systems and human knowledge into one code, The Game. Once you enter this universal language, you can integrate all aspects of human experience. Marcel Duchamp is the "Magister Ludi."

meanings which otherwise would not be well rendered and would not strike us so deeply. Contemporary art has a proto-rational and proto-conscious quality that allows it to conduct an intersubjective dialogue, which reinvigorates spirituality. Conventional religion seems to be lacking spirituality. Particularly if we consider that the strongest faith today is fundamental-ism which, while energetic, is pervaded by reactionary laws and dogmas.

We need a great and faraway utopia in order to organize a very rich and complex present. In Baruch Spinoza's philosophy, God the creator and mankind, his creation, are one. I see a similar union between the contemporary artist and his work. And in this sense art can replace religion for certain individuals.

There was modernism before the Holocaust and modernism after the Holocaust. World War II chan-neled the energy of European art into a more human/anthropologi-cal practice. In contrast, driven by Clement Greenberg, much of

ART RELIGION

Art today can surpass the two pervasive theories confronting our post-capitalist world: the pseudo-democratic relativism of postmodernism vs. the oppressive dictatorship of fundamentalism.

post-war American art focused on formalistic concerns oscillating between the sublime and the merely entertaining.

Referring to *The Bride Stripped Bare by her Bachelors, Even* in a 1966 interview with Pierre Cabanne, Duchamp said, "...I almost never put any calculations into the *Large Glass*. Simply, I thought of the idea of a projection, of an invisible fourth dimension, something you couldn't see with your eyes." Is this not the domain of the divine?

I am reminded of an observation I made in 1974, documented in a catalog from that time: "Art is unverifiable [as is the idea of God], we can merely approach it through exercises [prayers], which sometimes surmount their own limits and provide us with a spirituality of expression if we are artists, and a spirituality of perception if we are observers."

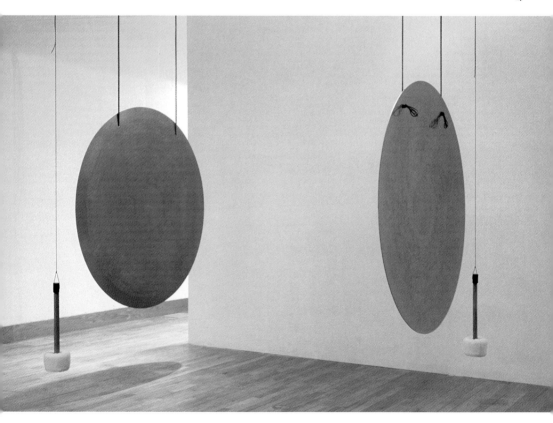

Jaume Plensa, *Born-Die* (installation view), 1998

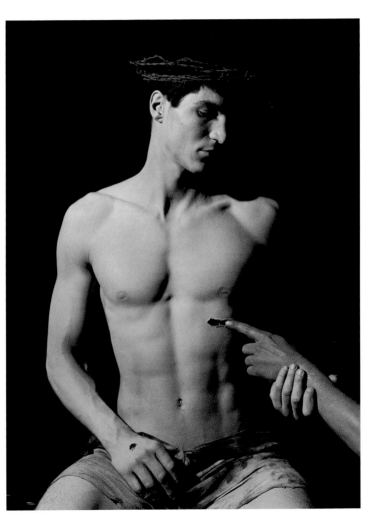

Bettina Rheims & Serge Bramly, *Doubting Thomas*, 1997

Matthew Ritchie, *Chapel Perilous* (installation view and detail), 2000

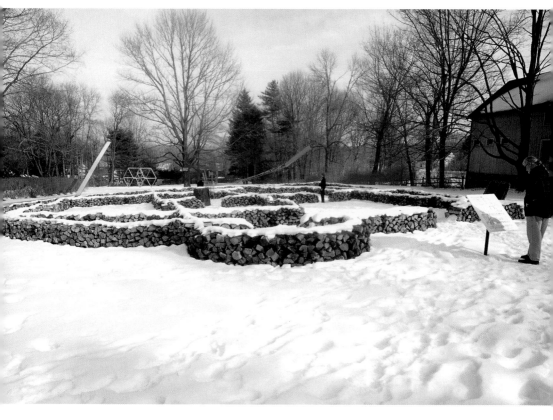

Osvaldo Romberg, *Syzygy II*, 1999-2000 in collaboration with Montclair State University first year graduate students Christopher Corey, Peerayot Gwilliam, Joanne Lefrank, Cristina Pineros, Paul Sheilds, and Dmitri Wilkins, as well as with the MFA program's 1999-2000 Critic-in-Residence Dominique Nahas

Diane Samuels, *Letter Liturgy (for Leon)* (detail and installation view), 1993-99.
Text embroidered on book reads: Dear God, I do not know how to pray, but I can recite
the alphabet. Please accept my letters and form them into prayers.

reflecting on that world not as it is, but as one might imagine it put back together again

Francesc Torres, *Learn*, 1998

CONTEXTS: JEWS AND ART AT THE END OF THE MILLENNIUM

Ori Soltes

RELIGION, ART, POLITICS, AND WORDS

Religion and art have been interwoven as long as human visual self-expression has been recorded. Religion presupposes the existence of an Other (let us call it Divinity), which has created us with some purpose in mind, is interested and involved in human affairs, can further us or hinder us, harm us or help us—and which, having created us, can also destroy us. Divinity is the source of blessing and curse, hope and fear. Every religious tradition derives, ultimately, from this presupposition. The purpose of every religious tradition is to wrestle with what Divinity is and what It wants of us, in order that we may survive and be furthered and helped, rather than destroyed.

Prophets and priests derive their position of leadership from the further assumption that Divinity communicates directly to them—that It reveals Itself to them as It does not to you and me. Such individuals might be categorized as falling between Divinity and Humanity: they receive information from Divinity for us, and carry back our praise and prayers. This category also includes heroes and the kinds of leaders—pharaohs, shahs, kings, emperors—whose constituencies believe that they also have, either genetically or by favor, a connection to Divinity that the rest of us lack.

Religion has a handful of important instruments with which it communicates to us what Divinity is and interprets revelations regarding what Divinity would have us be. One is the verbal instrument of prayer and myth; music and theatre are two more. As far back as we can find it, visual art has also functioned in the service of religion in helping the constituency of a given tradition to understand the nature of Divinity, the story of Its interface with us and Its demands of us. Art makes concrete the abstraction of Divinity by enabling us to see It—or at least to see the consequences of Its intervention in our reality: our hoped-for survival.

The earliest surviving sculptures—small neolithic works, like the so-called *Venus of Willendorf*—are visual embodiments of the abstract concept of fertility. All breast, belly and pubic area, with a faceless head dominated by hair which resembles the rows of a well-plowed field, the Venus's purpose relates to the same purpose for which religious ritual serves: to assure our survival. For if women—or our fields—are not fertile, we perish. Similarly, the ear-

Venus of Willendorf, 25,000 BC. Naturhistorisches Museum, Vienna, Austria. Photo: Erich Lessing/Art Resource, NY.

liest paintings, such as those in the caves of Lascaux and Altamira, are overrun with images of bull and bison, and of wild animals being successfully hunted. The first-mentioned animals embody male fertility; the hunted animals seem intended to remind Divinity to provide ample game for the community's survival.

The synthesis between continuity and transformation furthers the relationship between religion and art. Images repeat themselves again and again in various cultures and traditions. In the Near East and East Mediterranean, for instance, one notes both that powerful gods—Zeus, Poseidon, Marduk, Ba'al, Apis, Dionysius, and others—are repeatedly likened to, or offer important avatars as, bulls, and that images of bulls abound. On the other hand, variations and often subtle alterations of an image, while retaining the essence of its idea, will be seen, century and millennium by century and millennium. Bulls' horns become the horns of the crescent moon or of the double ax; heroes subduing forces of chaos, symbolized by two wild beasts between which the hero stands, become priestesses controlling two serpents, or a tree between two winged bulls, or a column between two lions.

Moreover as art serves religion, religion serves politics—and so art serves politics. The representation of the Egyptian pharaoh as a god, or having the wings of a god (the falcon-god, Horus, for example) around his shoulders serves to remind his constituency of his divinely-connected accomplishments and leadership. The same applies to images such as that relief carved on a stele from Babylonia (ca 1750 BC), which shows Hammurabi receiving the code of laws which bears his name from none other than the sun god itself; or the wall-painting from the mid-thirteenth century AD, in the Cathedral in Monreale, Sicily, which shows William II being crowned by no less than Christ on His throne. This artistic device applies more subtly, but just as significantly, to images such as that (from 983 AD) in the *Registrum Gregorii*, which depicts Otto II receiving the homage of the nations. We see him seated on a throne with a sphere in hand, flanked by four female figures. The viewer would associate the image—no doubt unconsciously—with familiar ones of Christ enthroned, or of the Virgin and Christ Child enthroned, *orbis mundi* in hand, and flanked left and right by saints or figures representing the four gospels.

100

To a believer, the pharaoh as god or god-favored is real; to the historian looking from the outside, the image intended to convey such a message is propagandistic. In an analogous but more troubling manner, what one tradition views as pious or sacred another may see as sacrilegious. For every religious tradition, interpretation is the second story of its edifice—built on the first, revelation. For after the death of the founding leader(s), the followers and devotees of the generations which ensue down through history are caught between the problems of memory (did s/he say this or that?) and understanding (did s/he mean this or that by what s/he said?). Thus it stands to reason that images which serve religion succumb to disagreement regarding what is religious and what is sacrilegious.

Differences of interpretation may occur within a given tradition—as when the inhabitants of Kos were scandalized by Praxiteles' representation, in 440-430 BC, of the goddess Aphrodite as a full-sized nude young woman rising from her bath. It was less the artist's banalization of the idea of her birth from the sea that offended them, than the fact that the goddess was being too obviously reduced to mere human status—they knew that the model had been Praxiteles' lover, Phryne. The Knidians, however, were impressed enough to accept the sculpture for themselves and to build a new shrine to house it. Debate about the piety of an image may also occur between traditions—as, for instance, when Chris Ofili, an artist of Nigerian descent, includes elephant dung on the surface of a painting of the Virgin Mary. Elephant dung, which is venerated in Nigeria (because of its double significance, of virility—the elephant itself—and the compost-fertility of dung) might evoke horror on the part of Catholic viewers, as recently happened at the Brooklyn Museum of Art's *Sensation* exhibition.

Religion addresses Divinity, which is deemed absolute by Its constituency, but how to understand that Divinity, and how and what to regard as appropriate or inappropriate with respect to Its visual representation, is relative. Since each tradition has its own sense of precisely what Divinity is, each has its own sense of what constitutes Its legitimate or illegitimate address. Moreover, the addition of words and texts in the form of titles or description may end up identifying a work as religious, sacrilegious, or altogether secular. If the aforementioned Virgin Mary was simply labeled "Young Woman," it might not have sparked controversy.

Similarly, if Andres Serrano's 1987 photograph of a crucifix in yellow liquid was called not *Piss Christ*, but, say, *Christ Immersed in Yellow Liquid*, it might not have

been perceived as sacrilegious. Indeed, it might have been perceived as an expression of emotional passion, as in Gauguin's 1889 *Yellow Christ*. It might have been perceived as an ironic exploration of the Jewishness of Jesus, through the negative association of the color yellow with Jews by way of the long-held association of that color with Judas and of Judas with Jews in Christian art. Associated with the yellow stars that Jews were forced to wear during the Holocaust, it might have been viewed as a commentary, akin to that found in Chagall's *White Crucifixion*, on the crucifixion of Jewry by a Christian world for whom the defining attribute of God—mercy— was apparently missing when six million Jews were being systematically tortured and destroyed.

Thus the words connected to the images in the titling of art, particularly contemporary conceptual art, can be as significant as the images themselves. If every work of art is completed by the viewer, who sees and responds to it by interpreting or seeking to understand it, then the labels imposed on art—whether by the artist or a curator—become part of the large process of connecting our reality to Divinity.

Artists provide a means by which a constituency can connect to Divinity by visualizing It or Its actions. In this role artists function as analogues of priests, prophets, heroes, kings, shahs, and pharaohs. The prophet serves as a conduit through which God speaks out, and the poet who recounts the stories of creation can only do so if the gods themselves have filled him with the knowledge of such things. The visual artist is inspired—*in-spirited*—to produce visual reflections of the Divine and Its relationship to us. This principle is overt where ritual objects and artworks with religious subject matter are concerned. But it can also be obliquely true for artists whose works are secular, for they emulate God-as-Creator.

THE PROBLEM OF "JEWISH" ART

For Jewish art, the issue of visualizing Divinity generates an obvious question. How can an invisible God be visualized? How can the absolutely metaphysical be physically

Marc Chagall, *White Crucifixion*, 1938. Oil on canvas. Gift of Alfred S. Alschuler. Photograph courtesy The Art Institute of Chicago. ©2000 Artists Rights Society (ARS), New York/ADAGP, Paris.

represented? Indeed, can there be "Jewish" art, given the Second Commandment? The answer to the question "how" has tended, historically, to fall in two directions: abstract symbolism and synecdoche.

Although Christian art is certainly subject to the symbolism of color, number, geometric, and vegetal form, Jewish art is more intrinsically dependent upon it. For instance, the notion of salvation came to be conveyed above all, in Christian art, through the figure of Jesus on the Cross. By contrast, Jewish art historically offers the idea of redemption primarily through the non-figurative image of the seven-branched candelabrum—the *menorah.*

This form not only connotes the hope for the messianic-era rebuilding of the Temple of which it once was the central artifact, but, in its abstract *sevenness*, it is the reminder of that most insistent of commandments: to keep the seventh day holy. This injunction was articulated both before Sinai (Exodus 16) and at Sinai (Exodus 20) in the moment of affirming the Covenant, with all of its implied and explicit promises and responsibilities—in the midst of the redemption from servitude and the passage to freedom. Thus the *menorah* symbolizes all of this.

The other means that Jewish art historically utilizes for representing God, or the relationship with God, is synecdoche: using a part to imply the whole. In early synagogue art, for example, in figurative scenes of the *Binding of Isaac* (from Genesis 22), at Dura Europus (ca 250 CE) and Bet Alpha (ca 520 CE); or of the raising of the refleshed bones of the righteous (from Ezekiel 37) at Dura Europus; a hand reaching out of a kind of sunburst is depicted. Thus without committing the sacrilege of representing the unportrayable God, the artist gives us the hand of God—not as metaphoric turn of biblical phrase, but as literal image—in action. We see, even as we do not see, the God of Israel.

This issue of representation, in turn, yields the question: what do we mean, exactly, by "Jewish art"? And what are its parameters across history and geography? How does the answer to this question affect the work of Jewish artists at the end of the twentieth century?

The definition of Judaism, Jews and the term "Jewish" is problematic, both historically and conceptually. Abraham was called a Hebrew. His grandson, Jacob, was renamed Israel, following a supernatural all-night wrestling match (described in Genesis 32:25-29). And so his descendants were called Israelites—who eventually

comprised a kingdom of tribes named after Jacob-Israel's sons. One of those sons, Judah, yielded that tribe called Judaeans—whose descendants split, ultimately, over the question of whether or not God assumed human form in the person of Jesus of Nazareth. One group called themselves Jews; the other, (not clearly distinguished from the Jews until the late first and early second centuries), called themselves Christians.

Thus if we consider Jewish art historically, we must begin our examination with the second century, when what we would recognize as Judaism had clearly begun to take shape. Yet to speak of anything Jewish as if it began at that point, without reference to developments from Abraham to Jesus, would be to consider the edifice from the second floor up, without its foundations and first story. And conceptually, is Judaism a religion? A nation? A body of customs and traditions? An ethnic group? An historical configuration? A people? A civilization?

If art has served religion throughout the ages, how does Jewish art serve Judaism to the extent that it is a religion? Interestingly, the Second Commandment proscribes making images for worship, not image-making per se. Through the centuries, there has been considerable visual self-expression among Jews, even as there have been times and places where the Second Commandment *was* interpreted to prohibit the very making of any representational images. Productivity was rarer, compared to what was found among Christians or Muslims, due to unstable circumstances and the lack of government or large-scale communal patronage.

Art is also understandable as the reflection of the artist's experience of reality. Is "Jewish" art, then, simply the reflection of Jewish experience? However, that experience is extremely varied depending upon time and place: that of a Jew in Auschwitz, Poland, in 1944, to take an extreme example, will differ from that of a Jew in New York City in 1999. Thus to say that Jewish art reflects Jewish experience provides an answer to the question without really answering it.

When one discusses "Jewish art," indeed, is one discussing the art itself or the identity of the artist? If the art, then are we discussing particular symbols? style? subjects? content? intent? If the artist, do we mean that s/he is Jewish by birth? conviction? Must the artist be consciously trying to make "Jewish" art? What of conversion: will the art of someone who converts into or out of Judaism suddenly become or cease to be "Jewish"?

Rembrandt van Rijn, Portrait of Rabbi Manasseh Ben Israel, 1643. Etching. Courtesy Rijksmuseum, Amsterdam.

An eighteenth century French silver spice box for *Havdalah* (the ceremony of exiting the Sabbath on Saturday evening) will be defined as "Jewish" because of the purpose it serves, although the anonymous artist was almost certainly a Christian; whereas a brass and silver Mosque lamp made in eighteenth-century Syria, for example, which will almost certainly have been made by a Jew, might thus be labeled "Jewish," in spite of its purpose.

How shall we classify Rembrandt's sensitive, soul-depicting portrait of the Amsterdam rabbi, Manasseh Ben Israel, as opposed to the far more pedestrian, postcard-like image of Manasseh by the Jewish artist Salom Italia? And how will we label a landscape by Pissarro or a portrait by Modigliani? Aside from the fact that both artists were Jewish, we are not likely to classify their paintings as "Jewish" unless we can identify specific features of a particular work, or of their work as a whole, that would cause us to say that what we see before us on the canvas would have been different had they not been Jewish.

To complete a circle: we began by observing that certain symbols, in particular the seven-branched *menorah*, have been used throughout the centuries to express Jewish memory and hope. Other important ones include a pair of columns, to represent the Temple in Jerusalem; the rampant lion, to represent the House of David (and thus Messianic hope); and the Tablets of the Law as synecdoche for the entire Torah—the bridge between God and Israel. Conversely, the configuration which is today most familiar as "Jewish," the six-pointed star, has a long pre-Jewish history, and has also long been part of Christian symbology (to signify the Davidic descent of Jesus). It only became universally viewed as a Jewish symbol with the advent of the modern Zionist movement at the end of the last century.

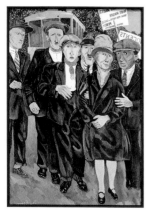

Ben Shahn, *Demonstration in Paris for Sacco & Vanzetti (Sacco & Vanzetti Series)*, 1931-32. Gouache on paper mounted on masonite. Private Collection. Photo: Scala/Art Resource, NY. ©Estate of Ben Shahn/Licensed by VAGA, NY.

JEWISH ARTISTS AND THE HOLOCAUST

The difficulty of defining Jewish art is part of the legacy inherited by Jewish artists in the twentieth century. Individuals like Jules Pascin or Raphael Soyer offer little that would be construed as specifically or obviously Jewish in their work. Ben Shahn, on the other hand, in addition to occasional overtly Jewish subjects, traced the consistent socio-political concerns of his work to his Jewishness and the heritage that he perceived himself to have carried forth from the Biblical prophets. Artists like Marc Chagall or Jacques Lipschitz might load their work with obvious Jewish elements—from Chagall's use of Yiddish and Hebrew in his paintings to Lipschitz' visual *midrashim*[1]—but might also use elements drawn from the Christian tradition.

One of Chagall's most extraordinary paintings is the earlier-mentioned *White Crucifixion* (1938). The canvas is aswirl with both white light and violence: a synagogue on fire, a topsy-turvy village, figures fleeing with packs on their backs or Torah scrolls in their arms, Jewish elders hovering in horror (where in a traditional Crucifixion, angels might be depicted weeping). Christ is wrapped in a loincloth that looks remarkably like a Jewish prayer shawl, a *tallit*. A Torah in the lower right hand corner of the canvas—falling out of the picture plane—emits a lush white fire (rather than being consumed by it) which licks at the foot of the ladder leaning against the cross. In a traditional scene, such a ladder would be part of the Deposition, with Nicodemus and/or St. Joseph of Arimathea lovingly and carefully removing the body from the cross. The ladder here is not merely empty; there is an enormous, pregnantly empty space around it—the only empty space on the canvas.

The sum offers us a dark vision: this is not the Savior of humankind, but a suffering Jew for whom there is no redeemer and no salvation in the Christian world leading into the Holocaust. This pessimism is confirmed by the most obvious other symbol in the painting: the *menorah* at Christ's feet. It has only six candles. The redemp-

1 *Midrashim* (sing = *midrash*) literally "dig beneath the surface" of the Torah or similar text. *Midrashim* are an important part of rabbinic literature. Lipschitz is one of many artists who visually recast familiar stories as, for example, when he represents Prometheus wrestling (rather than having his guts eaten by) Zeus's eagle in a manner recalling Jacob wrestling the angel: his *midrash* revisions two stories, from the Greek and Hebrew traditions, as one.

tive seventh, Sabbath-related candle is missing. The artist has changed the most traditional of Jewish symbols— as he has transformed the most traditional of Christian subjects into an elegy for Jesus as the paradigmatic suffering Jew, a savior for whom there is no salvation. The time of Chagall's painting is November 9, 1938—known as *Kristallnacht*, "The Night of Broken Glass"—when state-orchestrated rioting against Jews, Jewish homes, and Jewish businesses throughout Germany first formally placed physical violence on the Nazi agenda.

The subject of the Holocaust has evolved as one of the most frequent reference points for Jewish artists in the second half of the twentieth century: hardly any Jewish artist in our era can avoid addressing the issue one way or another, whether subtly or stridently. Some of the earliest responses are rarely recognized as such. The chromaticists among the abstract expressionists who dominated the New York art scene in the 1950s were mostly Jews. Marc Rothko, Barnett Newman, Adolph Gottlieb, to name some of the most prominent, were by no means observant Jews. But Newman began to study Yiddish in order to read Yiddish-language newspapers—in particular those with a more socialist bent. The discussions that kept them all up late at night included the question of what, if anything, their art had to do with their Judaism, whether there might be such a thing as Jewish art, and how their art might be an instrument of response to the Catastrophe[2].

Their enormous, unframed canvases became part of the answer. Where the actionist works of non-Jewish expressionists like Pollock and De Kooning may be seen to reflect the explosion of the world expressed by the cataclysms of the first half of the century, the works of Rothko, Newman, and Gottlieb put the world back together. One's eye is drawn toward the center of a Rothko or a Newman; chaotic forms are framed in a unifying white in Gottlieb's canonical works of that period.

In short: such works follow the long-articulated Jewish obligation of *tikkun olam*—repairing the universe, leaving it a better place than it was when one entered it. This concept reached a high-water mark of expression in Tsfat, Palestine, in the sixteenth-century mysticism of Rabbi Isaac Luria, whose thought was among the issues discussed by the Jewish chromaticists. Their enormous canvases offer a kind of secular messianism, a reflection not of the world as it is, but as it could become if we actively restore it, repair it. Such works offer the irony of being touted by mod-

2 See Barnett Newman's writings and manifestos from that era, and the discussions in *American Artists on Art from 1940 to 1980*, ed. Ellen H. Johnson (New York, 1982), p 19; Harold Rosenberg, *Art & Other Serious Matters* (Chicago, 1985) (re-printed; original publication 1967), especially pp. 268-9; and Dore Ashton, *The New York School: A Cultural Reckoning* (New York, 1972), pp. 72-3, 126-33—where, it must be noted, Ashton, quoting Thomas Hess's 1930s quoting of Newman, sees only an interest in anarchist politics in the artist's decision to learn Yiddish, the pre-eminent "Jewish" language of New York City in the 1930s.

Leon Golub, *Charnel House*, 1947. Lithograph. Courtesy of the artist.

ernism as pure formal, non-narrative works, yet they also further the notion of a social significance to art—an idea that had been articulated first by Pissarro[3] (the lone Jew among the fathers of French impressionism) and brought to its figurative apogee in the social realist styles of Ben Shahn and Jack Levine, who were later obscured by abstract expressionism.

More often, Jewish artists responding to the Holocaust have done so in a more obvious manner. From Ben Zion's series, *de Profundis* (1943; Ben Zion was part of a group called "The Ten" which originally included Rothko) and Leon Golub's *Charnel House* (1946) to Marty Kalb's *They No Longer Cry* (1993) images, scores of Jewish artists have felt the need to respond to the event in a manner representational enough for there to be no question as to the horror which has inspired them. Others, like survivor Kitty Klaidman (as in her 1992 *Abstracting Memory* series) have produced work which falls on the border between the representational and the abstract, so that it is the titles and/or the viewer's awareness of this period in her life which clarify the subject behind her work.

Some Jewish artists have developed their own vocabulary of reflection on the Holocaust. RB Kitaj, for instance, decided that, given the significance of the Holocaust, the most important symbol in Jewish art in the last part of the twentieth century should be the chimney. For him this became a recurrent motif by the 1980s, although for others, alternate symbols have offered that resonance. Railroad tracks are one example—leading, ladder-like upward (but to nowhere except the oblivion beyond the canvas), or converging to a vanishing point deep within the picture plane. Suitcases, piled up or in spaceless isolation, connote the Jewish experience of aloneness—suitcase in hand on the railroad platform to the concentration camp—joined to the universal idea of aloneness experienced by any traveler in an alien setting. Indeed, many Jewish artists have used the Holocaust as a stepping-off point for a broader visual discussion of human violence and brutality.

Interestingly, the kind of question which provokes Jewish and Christian theologians, and which is so often reflected in writing about the Holocaust—the presence or

3 See *Camille Pissarro, lettres a son fils Lucien*, ed. John Rewald (Paris, 1980). Pissarro's correspondence with his son, Lucien, in which he comments on the obligation of the artist to be concerned not only with aesthetics but with social issues, and to share what he has learned with the world at large, not only with artists.

absence, nature and/or very existence of God—is addressed rather infrequently in such art. Even the works of Rothko and Newman, which I have termed messianic, are messianic for a secular, social context. In fact, with notable exceptions, Christian writers are more wont to ask the question of how the Holocaust could have happened given a God of mercy, while Jewish writers are more inclined to analyze the question from the perspective of the historical development of anti-Semitism. The Jewish art which addresses the Holocaust is most likely to address its subject from an entirely human perspective: it reflects on what humans wrought against humans, it dwells on the specifics of an extraordinary human experience derived from twisting human creativity into the most perverse of shapes.

MEMORY, IDENTITY, AND QUESTIONS

Jewish artists are not alone in addressing the Holocaust, but it occupies an inordinately large space within their focus. For them it is part of a larger issue, a cornerstone of Jewish life and history: memory. Conscious connection to a long past is an important part of the survival mechanism of a people that has been so physically disconnected in the course of the past two millennia. At the same time, the elements of connection—weekly, annual, life-cycle celebrations and commemorations—which have always been subject to transformations across Jewish history and geography, have been particularly susceptible to reshaping by Jewish artists in the late twentieth century.

One thinks, for example, of Allan Wexler's *Indoor Sukkah* (1991). It plays on part of the cultural history of Judaism: the gastronomy of its tribal celebrations. Traditionally the autumn festival of *Sukkot* commemorates the forty years of Israelite wandering in the wilderness, when the people dwelled in booth-like structures, called *sukkot*. Vegetal and

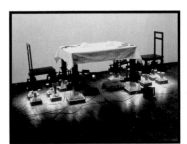

Allan Wexler, *Indoor Sukkah*, 1991. Mixed media. Collection of the Jewish Museum, NY. Courtesy Ronald Feldman Fine Arts, Inc., New York.

fruited accoutrements hanging from the *sukkah*'s open ceiling beams also celebrate the bounty of the divinely-aided fall harvest. Wexler has turned it upside down: it is the floor, not the roof, which is marked by sixteen plantings—two for each day of the festival—which grow through the use of lamps, thus turning indoors into "outdoors." Fall thus becomes spring, dying becomes birth, the communal table, set for two, directs us to the earth, rather than toward heaven. It is the evolving, ever-organic traditions, constantly reshaped by human need and response, that Wexler marks—as opposed to focussing on the initial Divine commandment to keep them.

In a different manner, Sy Gresser's large Texas limestone relief sculpture, *Last Supper* (1994), is also largely driven by, and reshapes, history and memory. It reminds us that Jesus' last meal was a Passover Seder. It includes among the assembled faces an African (the dark face is *not* Judas), a Canaanite (modeled on his own grandfather's face, and thus connecting personal with tribal memory), and an Egyptian (the traditional bad guys in the Passover story). In this he visualizes the fulfillment of the opening inclusive statement of the Passover meal—"all who are hungry, enter and eat." Gresser reflects on this only from a historical and cultural, not a religious, viewpoint: God is not part of the scene that he shapes. Yet both Passover and *Sukkot* are part of that larger pattern of memory which begins as a Divine commandment not to forget the experience in and coming out of Egypt, and God's role in that experience.

Why does Gresser call his Passover Seder *Last Supper*? It is, in part, simply to remind us of the historical connection between those two meals. But that desire is driven by a broad-based humanism that seeks to heal the historical rift between Judaism and Christianity (as among Israelites, Canaanites and Egyptians). It is another version of *tikkun olam* sensibility. This work also incorporates another leitmotif of Jewish artistic activity that has grown with our century: questioning precisely where a Jewish artist fits into the Western tradition of art-making, since that tradition is essentially Christian—or was, at least, until a few centuries ago.

Osvaldo Romberg's constant play with images from Caravaggio's religious paintings, to which he often adds details in the form of Hebrew letters and words, may be seen, in part, as an instance of addressing that question. What was a Christian subject for Caravaggio acquires a Jewish patina from Romberg. Jewish artists frequently do this by making use of the triptych form, which is so integral to the history of Western/Christian art, symbolizing the trinity and generally offering either a crucified

Christ flanked by the crucified thieves and/or by the Virgin and John the Evangelist; or a central Virgin and Child, flanked by saints. Yaacov Agam's 1966 triptych, *T'filah*, meaning prayer, offers his characteristic op art presentation: as the viewer moves across the picture plane, the abstract image also moves. In other words, we see not a static image, but one that is always changing; where the tangible figurative Christian God would be, the invisible Jewish God has been "un-represented" by ungraspable abstraction. Susan Schwalb's *Creation Series* triptychs of the early 1990s combine particular geometric abstractions—inspired by the fourteenth century *Sarajevo Haggadah*—with the symbolism of earth and heaven colors and the Renaissance technique of silver point, copper point and gold-leaf.

Other Jewish artists have used the triptych with a still more stridently Jewish nuance. Some, like Francia Tobacman, have associated its pattern with the three-fold doorway of the early synagogue—an architectural feature later integrated into the church. For the synagogue it reminded the congregation of the three-fold courtyard of the Temple, and of the threefold ritual division of Judaism into *Kohayn* (High Priestly family), *Levite* (Priestly tribe of Levi), and *Yisrael* (everyone else); for the church it came to suggest the Trinity through which one enters the cruciform structure which signifies the body of Christ. For other Jewish artists it represents the two thousand-year-old Jewish dictum that the world stands on three things: Torah, Prayer and Good Works. Naomi Geller Lipsky's *Three Gates* are drawn from a *Rosh HaShanah* (Jewish New Year) prayer that reminds us, at the border between one year and the next, of the importance of prayer, repentance and charity as a three-fold passageway to God.

On the other hand, the myriad cultural, as opposed to religious, questions of a Judaism interfacing with the secular yet Christian American world around us have provoked a response from Jewish artists, particularly as the ambiguously secure position of Jews in America has grown since World War II. The 1996 *Too Jewish?* exhibition organized by the Jewish Museum demonstrated this strongly. The exhibit was overrun with works that reflected, tongue-in-cheek, on stereotypes regarding noses, nose-jobs and name-changes; Jewish princesses and rampant materialism; physical beauty, finesse and strength—and icons that further or contradict stereotypes from Barbra Streisand and Bob Dylan to Sandy Koufax.

The focus on aspects of the body or of physicality relates to a concern about specific physical stereotypes. This contrasts with a prevailing lack of interest in the

human body as a vehicle for visual self-expression—and is different from the broader, religion-related interest in the body by Catholic artists. Is this because of the deemphasis on the figurative in the Jewish visual tradition? Is it because of the less emphatically negative emphasis on sexuality for Judaism than that expressed in the concept of Original Sin and the high honor accorded to celibacy? Or perhaps the images of degraded human bodies from Auschwitz have been too plentiful and too painful to encourage that focus.

But the *Too Jewish?* exhibit also showed how, at the same time, a growing number of artists—particularly American Jewish artists—in the past two decades have raised questions, not only with regard to the Western/Christian visual tradition, but as to where they fit into Judaism. Many young Jews turned everywhere but to Judaism to define themselves in the widespread search for roots which evolved in the late sixties and early seventies. By the eighties, in turn, many, now somewhat older, began to turn back to Judaism—but laden with questions. How does someone who doesn't believe in God, or doesn't believe in God's interest in and involvement with us, or doesn't, at least, believe that the Torah is simply and in its entirety the word of God, define himself as a Jew? How does one balance the beauty of ritual and its elements (in particular, for example, the gastronomic elements of the Passover celebration) with the commercialization imposed upon them—by Jewish manufacturers and advertisers?

Scores of Jewish women artists, from Helène Aylon to Carol Hamoy, have wrestled with the question of where and how, as women, they fit into the Jewish tradition, with its patriarchal history and the genderal separation, for prayer and ritual, to which it has been habitually subject. Jewish women artists can find and have found distinct female-excluding elements to question within the traditional structure of Judaism. Both Aylon and Hamoy have used Torah scrolls, prayerbooks and *tallitot* in their work, to comment on the traditional exclusion of women from important parts of Jewish ritual.

The first part of Aylon's slowly evolved four-part installation, *Trilogy and Epilogue* (1990-98), for example, deconstructs the Torah, extracting passages which she views as virulently misogynistic and inconsistent with a contemporary humanistic view. She seeks to reinstate the female presence where it has become occluded by centuries of ossified interpretation that accept such passages without question. As such, she effects *tikkun* on God, rescued from the malignancy of ossified ideology, and on God's Word—and therefore on the world that would live in the shadow of that Word.

gious, because something sacred—as you were suggesting—
involves the notion that the actual thing itself inheres in that object.
I'm thinking here of Russian icons or the Tabernacle. These are
things that are sacred and have a code to transgress that makes for
the possibility of sacrilege. But on the other side are representa-
tions, and this is certainly again going back to Catholicism, where
there is this whole tradition of representation of religious figures, of
Mary and the saints and Christ. These were never meant to be the
thing itself, are never understood to be the thing itself. Therefore I
think, because they are simply representations, there is a field of
play there for contemporary artists. Michael Rush: The problem
though becomes I think, Eleanor, when —I think what you say is
absolutely correct—but to the public, or to the faithful, as we used
to say, it does become the thing itself. I mean look at this relic of
Theresa of Lisieux. I mean part of her bones ... I don't mean to
offend anyone, but it's astonishing that in 1999 this is still going
on... what you say may be true, but I don't know that the faithful—
a tired old term I can't seem to get rid of—the faithful don't see it
that way, for them the image really is the... Eleanor Heartney: —but
theologically I think that's not correct . . . Michael Rush: —yes,
you're correct, absolutely it isn't . . . Marcel Brisebois: Emotionally
this is different, and think about, for example, the statue of St. Peter
in Rome. You have to touch, to kiss the Saint's foot—go to a museum
where the object is considered sacred and you have to refrain from
touching. The sacred commands different attitudes depending
whether you are in a church or a museum. Norman Kleeblatt: I happen
to think that some of the art experimenting the intersection of the
sacred and the secular challenges the stereotype. I see Serrano's
work as trying to elevate that "plastic" defilement of Catholic
imagery that he would have seen in these so-called sacred objects
stamped out of a machine. Serrano is able to transform them, to
make them transcendent aesthetically. I can't speak about being a
Catholic, but there will always be people who take sides. There was
a project at the Magnus Museum in Berkeley where an artist named
Albert Winn created a conceptual *mezuzah*. The *mezuzah* is the
container for the parchment scroll that sanctifies the front door of
every Jewish home. What he created was a separate parchment con-
tainer and surrounded the "holy" parchment with another vial that
held his HIV+ blood. He then asked people to walk through it, to
participate. He presented the work for the "Day Without Art." Well,
half the Jewish community came down thinking this was a really
radical rethinking of this liturgical object. The other half thought it
was the most horrible defilement. The flak died down. What I find
funny is that sometimes these religious communities then begin to
use these same artists initially so reviled, to show how spirituality
can function in a contemporary aesthetic. Sometimes confrontations
bring people back to religion. Being a person with AIDS, Winn redis-
covered religion because he was a man whose life was threatened.
He needed both the sense of community and the spiritual support.
The Jewish community that feels that his piece was an act of defile-
ment is denying him his access to his religion. I think it is this
yearning, this trying to come to terms with what this religion meant,
this religion that was too complicated to take in its totality as a daily

Symposium, October 8, 1999, The Drawing Center, New York City

dose. Nevertheless, religion has incredible power and meaning for them and helps define their identity. Michael Rush: That's where the collision occurs, isn't it today, because if contemporary art is art that is personalized extremely then how does the personal coexist with the institutional in a way—or the communal—in a way that can avoid conflict. It probably can't, I mean, and it shouldn't, but this is what's new, this is what's different about our age, I think. To me, were I a church person I would be excited about all this, because it is bringing interest to the church—discussion, vitality.

Symposium Participants: Marcel Brisebois is the director general of Musée d'Art Contemporain de Montréal in Canada. Eleanor Heartney is a writer and art critic. She is a contributing editor to *Art in America*. Norman Kleeblatt is the Susan and Elihu Rose Curator of Fine Arts at The Jewish Museum in New York. Michael Rush is a theater artist, filmmaker, and critic. He is the author of *New Media in Late 20th Century Art*. Ori Soltes is an independent curator and professorial lecturer at Georgetown University in the Departments of Theology and Art. Livia Straus is a professor of Education and Religious Thought at the Academy for Jewish Religion and adjunct professor in the Department of Theology at Fordham University.

Symposium, October 8, 1999, The Drawing Center, New York City

Conversely, one particularly positive aspect of genderal reflection is the creation, in the last few years, of a new ritual object, the *Miriam Goblet*, which re-introduces the sister of Moses and Aaron to the Passover Seder table, side-by-side with the Cup of Elijah. A growing number of Jewish women artists have added this to the repertoire of their creativity. Countless artists of both genders, in fact, have turned, in the past two decades, to the production of all manner of ritual objects, using motifs drawn from centuries of visual ideas, and to the shaping of synagogue arks or even abstract sculptures which contain symbolic elements inspired by ancient synagogues.

A growing number of artists have been addressing specific, deeper aspects of the Jewish tradition, such as mysticism. In part this reflects the intensified spirituality to which both Jews and non-Jews have been drawn in increasing numbers as the century and the millennium have rushed closer to their end. Here, too, the range of visual response to the mystical tradition has been considerable, from Charles Stern's gigantic *Hebrew Letters*, carved of Texas limestone, to Jane Logemann's repeating patterns of Hebrew (and other) letters and words to Marilyn Banner's *Soul Ladders* installations, all done in the 1990s.

Logemann's work, for instance, in which pale pigments wash over repeated words or letters, echoes the Jewish mystical principle of repetition of sounds and words to the point of trans-sensibility. At the same time its graduated, nuanced changes reflect the kind of purely formal principles—art as simple color and pattern—of work like that of Sol LeWitt (who was her teacher), and also of the mesmerizing sound-repetitions found in the music of composers like Phillip Glass. Logemann's work is thus embedded both in the Jewish mystical tradition and in wider, secular and universalistic circles.

Marilyn Banner's work also touches on Hebrew letters, but often disguised as birds or other creatures forming part of the God-shaped world. Her *Soul Ladders* offer a connection between worlds, as they recall the vision of a ladder between heaven and earth experienced by the patriarch, Jacob, as he fled into the wilderness from his brother Esau's anger; and simultaneously allude to the ladder of the *spherot* delineated in the Kabbalistic *Book of Splendor*, the *Zohar*. There such an image at once suggests aspects of the aspectless Creator, aspects of the creative process, and aspects of the creation itself. For Banner this is further personalized —the artist is conscious of the processes of her own formation and her own creativity—by the images of

ancestors (including those perished during the Holocaust) which are often embedded in the flotsam and jetsam hanging from her ladders' rungs.

As one re-examines all of this, one is struck by the importance—and not only for artists whose work intersects Jewish mysticism—of letters and words. In fact, one of the more interesting aspects of visual art among Jews, who are sometimes referred to as the *People of the Book*, has been the more than occasional turn, throughout this century, to textuality. This is expressed in the importance and twist of titles—we are coming back toward where this discussion began—as in the work of Barnett Newman. Newman often accorded titles to his works which further accentuated the intent which would otherwise have been virtually invisible to the viewer—and which might still remain invisible to a viewer unaware of word-specific Jewish issues. Thus when he named an all-white (i.e. all-color-absent) canvas *The Name*, a traditional Jew, at least, would recognize that the title is the standard circumlocution for "God," which word (and its Hebrew equivalent) is never spoken outside the context of prayer, and for which the phrase "the Name" (*haShem*, in Hebrew), is substituted. The title tells those who understand its significance that this painting of color-lessness—which is, from a traditional painting-equals-color viewpoint, a non-paint-ing—can be seen as a non-portrait, a visual circumlocution, of the unportrayable God. One might say that he has solved the Jewish problem regarding the millennia-old purpose of art as serving religion by depicting Divinity. (We *have* come full cir-cle.) It may also be seen as a reflection on the issue of God's absence during the Holocaust, while offering the post-Holocaust *tikkun olam* that the unified light-whiteness of such a canvas offers.

The significance of texts is also within the works themselves, of course, from Chagall to Logemann. One sees this in the recent work, as well, of Diane Samuels, whose *Letter Liturgy (for Leon)* (1993-99) reflects on an old Hassidic story regarding what God accepts as piety: not book-learned knowledge of the prayer book or the Torah, but the purity of the heart's intention, symbolized by the illiterate Jewish peas-ant who cannot read the prayers but keeps reciting the Hebrew alphabet, allowing God to combine the letters into words. Samuels plays on the very abstract arbitrari-ness of letters as symbols that, in combination, represent words and ideas. Are the "letters" in her "book" letters? If not, is this a book? More importantly, can non-let-ters form the words which comprise prayers? Do prayers require well-wrought words

or, for a textual people like Jews, well-shaped letters? With what instruments—words? melodies? gestures? images?—does one most effectively address God? Is God listening and looking—and interested—anymore?

.

If, in looking back through this discussion, there is a common denominator, it is that of *asking questions*—about the world and the place of artists, Jews and Jewish artists within it. These may be questions without answers—certainly without simple ones. If questioning is by no means an exclusively Jewish art, it is certainly one that is repeatedly exhibited by Jews. And questioning also completes a circle for us, albeit obliquely: back to art as part of the process of addressing that Other which offers no obvious answers, except through moments of revelation like those that form the foundations of the Jewish and Christian traditions.

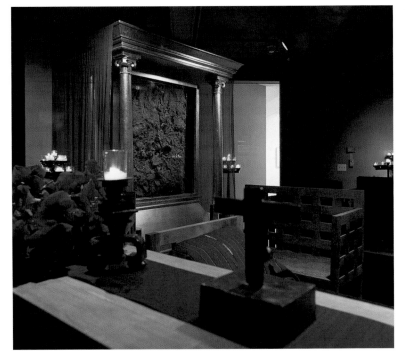

Michael Tracy, *Chapel of the Damned* (installation views), 2000

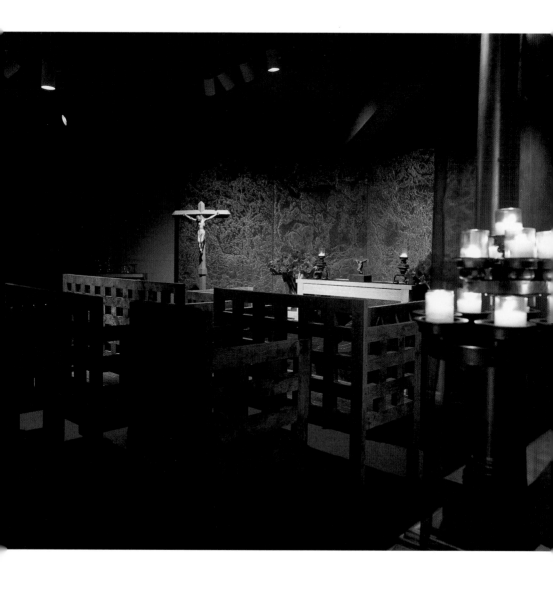

James Turrell in collaboration with William Burke and
Nicholas Mosse, *Lapsed Quaker Ware* (detail), 1998

sometimes it's more a parade than a procession

Lane Twitchell, *Poetry in Motion, October 27, 1989*, 1999

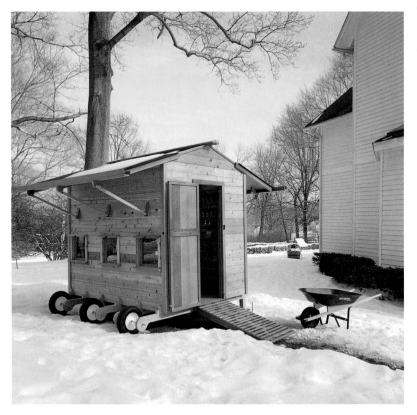

Allan Wexler, *Gardening Sukkah* (installation view and detail of interior with roof open), 1999

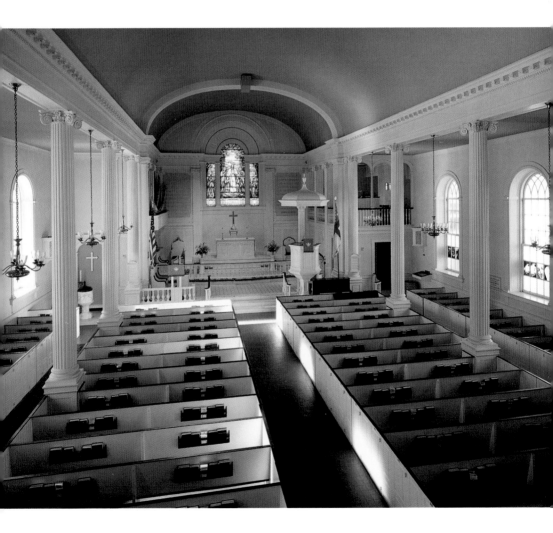

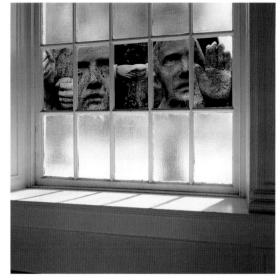

Jo Yarrington, *Tikkun Olam* at St. Stephen's Church (installation view and details), 1999

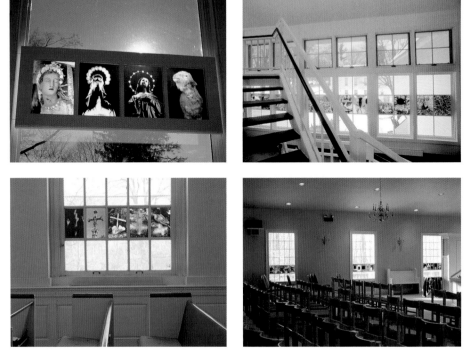

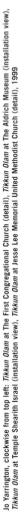

Jo Yarrington, clockwise from top left: *Tikkun Olam* at The First Congregational Church (detail), *Tikkun Olam* at The Aldrich Museum (installation view), *Tikkun Olam* at Jesse Lee Memorial United Methodist Church (detail), *Tikkun Olam* at Temple Shearith Israel (installation view), 1999

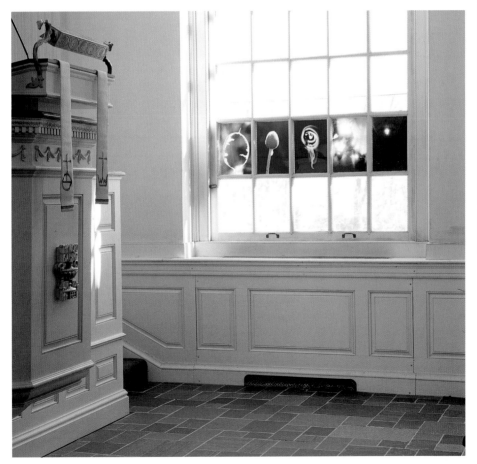

Jo Yarrington, *Tikkun Olam* at Jesse Lee Memorial United Methodist Church (detail), 1999

WORKS IN THE EXHIBITION

All dimensions h x w x d in inches
unless otherwise noted

Reverend Ethan Acres
Miracle at La Brea, 1997
Screenprint on Mylar stretched on
Plexiglas support
92 x 48
Collection of Fisher Gallery, University
of Southern California, Los Angeles,
Purchase Fund

Final Voyage of the Beagle, 1997
Screenprint on Mylar stretched on
Plexiglas support
60 x 38
Collection of Barry Sloane, Los Angeles

Courtesy Patricia Faure Gallery,
Santa Monica, California

Helène Aylon
My Notebooks, 1998
Mixed media installation with video
projection
Dimensions variable
Courtesy of the artist

Lisa Bartolozzi
Her Creation, 1997
Oil, beeswax on panel, shadow box frame
23 x 25 x 2
Collection of Ellen and Carl
Bartholomaus, Wilmington, Delaware

The Marking of Foreheads, 1994
Oil, ink, beeswax on panel
9 1/2 x 17 x 3 1/4
Collection of Creighton Michael and
Leslie Cecil, Mt. Kisco, New York

Messenger, 1991
Oil, ink, beeswax on panel
21 x 18 1/2 x 3 1/2
Collection of Creighton Michael and
Leslie Cecil, Mt. Kisco, New York

Willie Bester
Die Bybel, 1997
Mixed media assemblage
17 3/4 x 13 x 3 1/2
Courtesy The Goodman Gallery,
Johannesburg

Sylvie Blocher
Living Pictures/Are You a Masterpiece?,
1999
With the Princeton Tigers football team
Multichannel video installation
Courtesy Art & Public, Geneva

Barbara Broughel
Requiem Series, 1991
29 sculptures
Mixed media

Installation includes:

George Burroughs
Collection of Laurel Cutler, New York

John and Joan Carrington
Collection of Kenneth L. Freed, Boston

Lydia Gilbert
Collection of Piet and Ida Sanders,
Schiedam, Holland

Elizabeth Kendall
Collection of Boardroom Inc., Greenwich,
Connecticut

133

Alice Lake
Collection of Mark Wlodarczyk, New York and Wisla, Poland

Susannah Martin
Collection of Dr. Paul Monroe, Richmond, Virginia

Rebecca Nurse
Collection of Barbara and Ira Sahlman, New York

Wilmutt Redd
Collection of Frederieke Taylor, New York

Margaret Scott
Collection of Dorothy Bandier, New York

Goody Bassett, Brigid Bishop, Martha Carrier, Sarah Dashton, Mary Easty, Mary and Philip English, Dorcas Goode, Sarah Goode, Infant Goode, Nathaniel and Rebecca Greensmith, Elizabeth How, George Jacobs, Elizabeth Knapp, Sarah Osburne, Mary Osgood, John Proctor, Ann Pudeater, Mary Sanford, Sarah Wildes, John Willard

Courtesy of the artist, Barbara Krakow Gallery, Boston, and Frederieke Taylor/TZ'Art, New York

Petah Coyne
Untitled #983 [Mary Marilyn and Norma Jean], 1999-2000
Plaster and mixed media
102 1/2 x 164 x 27
Courtesy of the artist and Galerie Lelong, New York

Christian Eckart
Curved Monochrome Paintings, Fourth Variation, 1999
Acrylic urethane lacquer on aluminum
Triptych, 51 x 36 each
Collection of Luca and Nina Marenzi, London

Linda Ekstrom
Shroud of Jesus' Words, 1997
Scripture text, silk, thread
96 x 32 x 6

Isaiah, 1999
Silk, Hebrew text, wire, silver rod
4 x 3 3/4 x 3 3/4

Menstrual/Liturgical Cycles, ongoing since 1994
Menstrual blood, silk, text, wood table
33 x 96 x 36

Courtesy Frumkin/Duval Gallery, Santa Monica, California

Roland Fischer
Untitled, 1997 (Cologne)
C-Print mounted on aluminum
100 x 60 1/4

Untitled, 1997 (Strasbourg)
C-Print mounted on aluminum
71 x 99

Courtesy Galerie Von Lintel & Nusser, Munich, Germany

John B. Giuliani
Resurrection, 1992
Gesso and acrylic on wood
30 1/4 x 13 1/8
Collection of Karen Veronica,
Norwalk, Connecticut

Hopi Virgin and Child, 1995
Gesso and acrylic on wood
48 x 23 1/8
Courtesy of the artist

Jesus and the Disciples, 1995
Gesso and acrylic on wood
23 x 48
Collection of Jane and Timothy
McCaffrey, Westport, CT

Clara Gutsche
*Les Soeurs Adoratrices du
Précieux-Sang, The Gallery, Nicolet, 1995*
Chromogenic color print
15 x 19

*Le Monastère des Soeurs Clarisses,
The Meeting Room, Valleyfield, 1990*
Chromogenic color print
15 x 19

*Le Monastère des Soeurs Adoratrices
du Précieux-Sang, Utility Room, 1995*
Chromogenic color print
15 x 19

*Les Soeurs Adoratrices du
Précieux-Sang, The Choir, Nicolet, 1995*
Chromogenic color print
15 x 19

*Les Soeurs Carmélites, The Choir,
Montreal, 1996*
Chromogenic color print
15 x 19

*La Résidence des Frères Maristes,
The Parlour, Laval, 1997*
Chromogenic color print
15 x 19

Courtesy of the artist

Lyle Ashton Harris
Untitled (Face #50 Father Pierre),
1998-99
Unique Polaroid print
20 x 24

Untitled (Back #50 Father Pierre),
1998-99
Unique Polaroid print
20 x 24

Untitled (Face #34 Mother Dear),
1998-99
Unique Polaroid print
20 x 24

Untitled (Back #34 Mother Dear),
1998-99
Unique Polaroid print
20 x 24

Courtesy of the artist

Christof Klute
St. Jakob, 1996
C-print
49 x 39 1/3

Trinitatiskirche, 1996
C-print
49 x 39 1/3

St. Johannes der Täufer, 1998
C-print
49 x 39 1/3

St. Mechtern, 1998
C-print
49 x 39 1/3

Courtesy of the artist

Jan Knap
Untitled, 1997
Oil on canvas
23 5/8 x 31 1/2

Untitled, 1997
Oil on canvas
17 11/16 x 23 5/8

Untitled, 1997
Oil on canvas
35 7/16 x 27 1/2

Courtesy Sperone Westwater, New York

Kinke Kooi
Black Madonna, 1993
Acrylic and pencil on paper
24 1/4 x 19 1/4

Black Madonna, 1996
Acrylic and pencil on paper
18 x 14

0, God, 1999
Colored pencil on paper
21 3/4 x 28 3/4

Sunny Day, Happy Moment (3), 1995
Acrylic on photograph
30 3/4 x 19 1/4

Courtesy of the artist and Feature Inc.,
New York

Nicholas Kripal
Crown, 1999
Cast concrete, steel
61 x 74 x 46

*Sanctuary Font: Cathedral of San Zeno
Maggiore, Verona*, 1998
Cast concrete, water
34 x 22 1/2 x 34

*Sanctuary Font: Cathedral of St. Mark's,
Venice*, 1998
Cast concrete, terra-cotta, water
25 1/2 x 27 1/2 x 34 1/2

Sanctuary Font: Cathedral of Pisa, 1998
Cast concrete, steel, water
30 x 27 1/2 x 34

Sanctuary Font: Orvieto Cathedral, 1998
Cast concrete, wood, water
23 1/2 x 26 1/2 x 34 1/2

Courtesy of the artist

Justen Ladda
Tree of Knowledge, 2000
Stainless steel, Swarovski glass crystal
Approx. 7 x 6 x 6 feet
Courtesy of the artist

Maria Marshall
I'm not going to die easily, 1999
Laser disc projection
Dimensions variable
Courtesy Team Gallery, New York

Keith Milow
First Cross, 1999
Iron powder, resin, fiberglass
24 x 18 x 1 1/2

Fifth Cross, 1998
Iron on wood
24 x 18 x 1 1/2

Fiftieth Cross, 1976
Iron on wood
40 x 30 x 2

Seventieth Cross, 1976
Iron on wood
40 x 30 x 2

Courtesy Nohra Haime Gallery, New York

Hermann Nitsch
Installation Six-day-play, 1998
Mixed media
96 x 214 x 14
Courtesy White Box, New York, and
Heike Curtze, Vienna

Manuel Ocampo
Jesus Christ Kamasutra (AlpenLiebe),
1998
Oil on canvas
60 1/2 x 48 x 1 1/2
Courtesy Galeria OMR, Mexico

Jaume Plensa
Born-Die, 1998
Bronze, brass, string, wood, wool
2 gongs, each 51 1/2 in diameter
Courtesy Richard Gray Gallery,
Chicago/New York

Bettina Rheims & Serge Bramly
The Annunciation I & II, 1998
Photographs mounted on aluminum
Diptych, each panel 60 x 48

Doubting Thomas, 1998
Photograph mounted on aluminum
48 x 60

Courtesy of the artists

Matthew Ritchie
Chapel Perilous, 2000
Mixed media installation
124 x 143 x 143

Installation includes:

Itself Surprised, 2000
Oil and marker on canvas
78 x 100

The Idea of Us, 2000
Oil and marker on canvas
80 x 100

The Stronger Force, 2000
Oil and marker on canvas
84 x 100

Courtesy of the artist and Andrea Rosen
Gallery, New York

Osvaldo Romberg
Untitled, 1999
Oil on canvas
40 x 54
Courtesy of the artist and Heike Curtze,
Vienna

Osvaldo Romberg in collaboration with
Montclair State University first year
graduate students Christopher Corey,
Peerayot Gwilliam, Joanne Lefrank,
Cristina Pineros, Paul Sheilds, and
Dmitri Wilkins, as well as with the
MFA program's 1999-2000 Critic-in-
Residence, Dominique Nahas.
Syzygy II, 1999-2000
Cordwood, text on acetate, Plexiglas,
photocopies, paper, cardboard
4' x 93' x 83'
Courtesy of the artist and Heike Curtze,
Vienna

Diane Samuels
Letter Liturgy (for Leon), 1993-99
Desk, chair, audio recording, sound
equipment, hand-made book
37 x 32 x 23 overall
Courtesy of the artist and Kim Foster
Gallery, New York

Andres Serrano
Budapest (Mass), edition 2/3, 1994
Cibachrome, silicone, Plexiglas,
wood frame
65 1/4 x 54 3/4 x 3/4

The Church (St. Clotilde II, Paris),
edition 4/4, 1991
Cibachrome, silicone, Plexiglas,
wood frame
65 1/4 54 3/4 x 3/4

Courtesy Paula Cooper Gallery, New York

Claude Simard
Pulpit, 1992-93
Mahogany
106 x 48 x 48
Collection of Le Musée de la Ville de
Lachine, Québec, Canada

Francesc Torres
Learn, 1998
Mixed media
36 x 32 x 32
Courtesy Galeria Camargo Vilaça,
Sao Paulo, Brazil

Michael Tracy
Chapel of the Damned, 2000
Mixed-media installation
Dimensions variable
Courtesy of the artist

James Turrell in collaboration
with William Burke and Nicholas Mosse
Lapsed Quaker Ware, 1998
18 pieces of black basalt ware with
wooden cupboard
Approx. 36 x 20 x 12
Courtesy A/D, New York

Lane Twitchell
Poetry in Motion, October 27, 1989, 1999
Cut paper mounted on Plexiglas, acrylic
and collage
37 x 27

Stations of the Crossing, 1999
Cut paper mounted on Plexiglas,
and photographs
Diptych, 9 x 71 each

Courtesy Deitch Projects, New York

Allan Wexler
Gardening Sukkah, 1999
Mixed media
9' x 10' x 10' overall
Courtesy of the artist and Ronald
Feldman Fine Art, New York

Jo Yarrington
Tikkun Olam, 1999
A 5 site installation
Photographic tranparencies
installed on existing windows
Dimensions variable
Courtesy of the artist

DONORS, TRUSTEES, AND STAFF

Ridgefield Bank
Ms. Hinda Gould Rosenthal
Robert Saligman Charitable Foundation
Mr. Stanley B. Scheinman
Renate and Sidney Shapiro
Dr. and Mrs. Robert Soley
Mr. and Mrs. Robert Stavis
Mr. Michael Steinberg
Mr. Arthur Stern III
Sue and Marco Stoffel
Storm King Art Center
Susan Kasen Summer
 and Robert Summer
Mr. and Mrs. Anthony Ullmann
Mr. and Mrs. Jack Van Hulst
Mr. Leonard Wien

Director's Circle
Mr. and Mrs. Stefan Abrams
Mr. Glenn Bailey
Mr. and Mrs. Jay Bennett
Mr. and Mrs. Lou Brause
James Cohan Gallery
Mr. and Mrs. Michael Cohen
Danese Gallery
Mr. and Mrs. Joel Dictrow
Mr. Stuart Eichner
Mr. and Mrs. Peter Evans
Feigen Contemporary
Forum Gallery
Ms. Susan Freedman and
 Mr. Richard Jacobs
Sandra Gering Gallery
Ms. Susan Zises Green

Mr. Leo Guthman
Stephen Haller Gallery, Inc.
Ms. Georgeanne Heller
Mr. and Mrs. Michael Hort
Mr. and Mrs. Harry Huberth
Ms. Nash Hyon
Sean Kelly Gallery
Mr. and Mrs Louis Klein
Mr. and Mrs. William Kuebler
Lennon, Weinberg Gallery
Mr. and Mrs. Philip Lodewick
Marlborough Gallery
New York Community Trust
Mr. and Mrs. Nick Ohnell
People's Bank
Mr. and Mrs. Robert Perless
Marianne and Ed Pollack
Mr. and Mrs. Andrew Potash
Ridgefield Guild of Artists
Mr. and Mrs. Heiner Rutt
Mr. and Mrs. Alan Safir
Mr. and Mrs. Ira Sahlman
Mr. and Mrs. Peter Sahlman
Ms. Barbara Schwartz
Mr. Stanley Shenker
Ms. Laurie Tisch Sussman
Mr. and Mrs. Mark Theran
Ms. Ursula Von Rydingsvard
 and Mr. Paul Greengard
Ms. Shelby White
 and Mr. Leon Levy
Benjamin and Susan Winter Foundation
Yoshii Gallery

143